WHO AM I ?

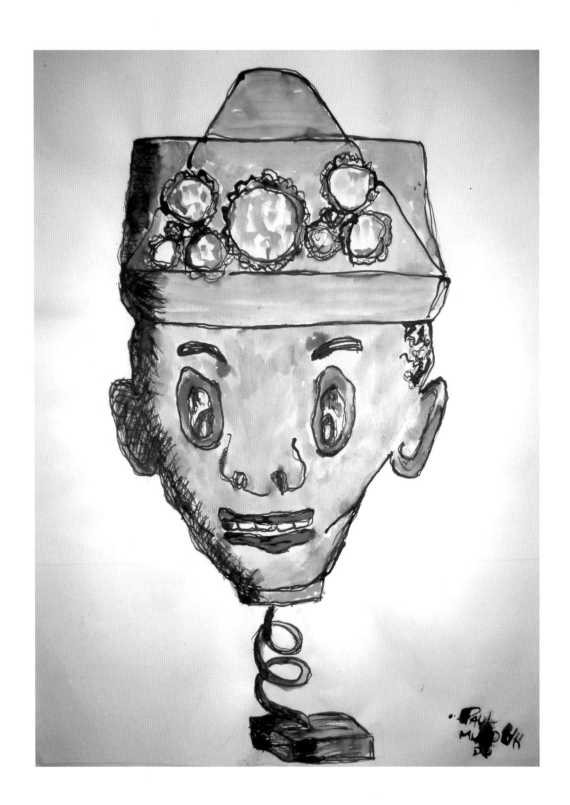

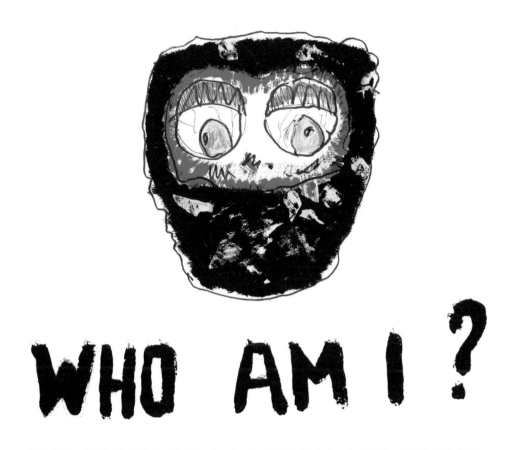

WHO AM I?

THE STORY OF A LONDON ART STUDIO FOR ASYLUM SEEKERS AND REFUGEES

TANIA KACZYNSKI

The History Press

This book is dedicated to my dear parents,
Marian and William Kaczynski,
who both passed away while I was writing it.
I know you can see from afar.
Who Am I? is for you both and for all refugees, past, present and future.

Front Cover: *Who Am I?* by Paul
Back Cover: *The Journey Continues* by Wallid (p.78)
Frontispiece: *Puppet King* by Paul

First published 2020

The History Press
97 St George's Place, Cheltenham,
Gloucestershire, GL50 3QB
www.thehistorypress.co.uk

British Library Cataloguing in Publication Data.
A catalogue record for this book is available from the British Library.

ISBN 978 0 7509 9301 2

Design by Katie Beard
Printed in Turkey by IMAK

CONTENTS

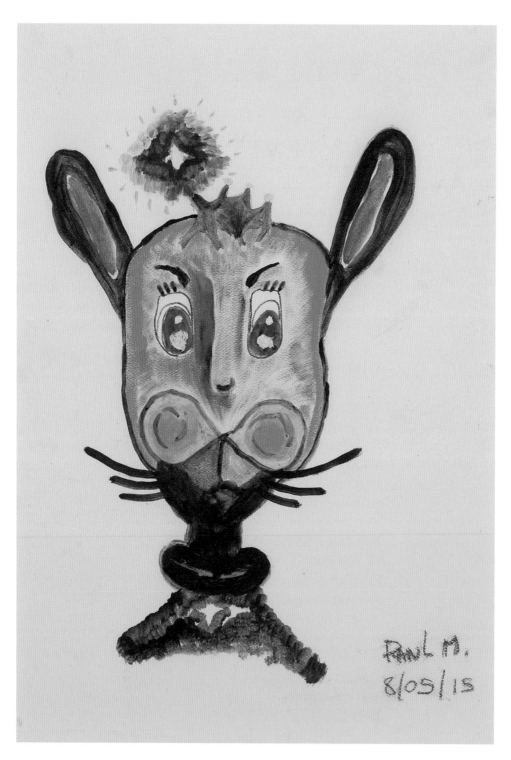

Crowned Creature by Paul

MAKING ART WITH THE DISPLACED

Here is a book like no other.

It tells real stories about real people, people who happen to be asylum seekers and refugees. Though we are bombarded with words about immigration, we seldom hear from the human beings at the heart of it, or see how the experience appears through their individual eyes.

Where there is war there will always be people seeking asylum. And there is always war. We are in the midst of the most urgent humanitarian crisis since the Second World War; there are currently over 70 million displaced people in the world, which means there are 70 million people without citizenship of anywhere.

These displaced people are people just like us.

One day, we might be asylum seekers too.

Who Am I? tells the story of a tiny art project that survived against the odds. It describes the creation of the New Art Studio and how two art therapists, Jon Martyn and I, joined forces with an international crew of the dispossessed to form an art collective unlike any other.

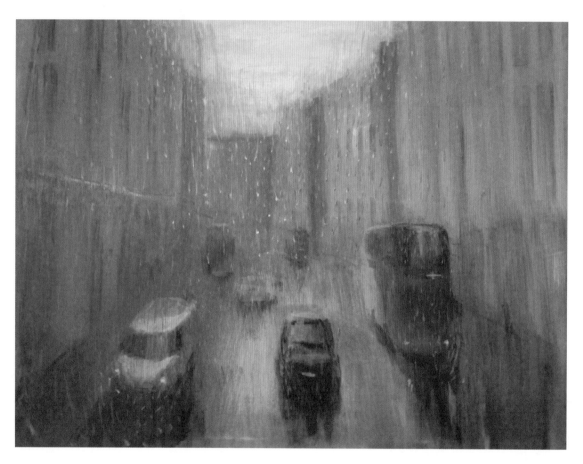

London Scene by Benjamin Croft

The lives of asylum seekers and refugees remain insecure even after they have lived in the UK for many years. In order to protect the individuals I describe in this book, all names and countries of origin have been changed or omitted.

I can, however, tell you that the studio is multicultural, and that we have members from Iran, Pakistan, Afghanistan, Russia, Ukraine and many more. Although our artists have their own distinctive style, each individual image exists thanks to the existence of the whole. The energy and spirit of the studio gives birth to the paintings. It is a very collective unconscious. In the same way it takes a village to raise a child, so it takes a studio to raise an artist.

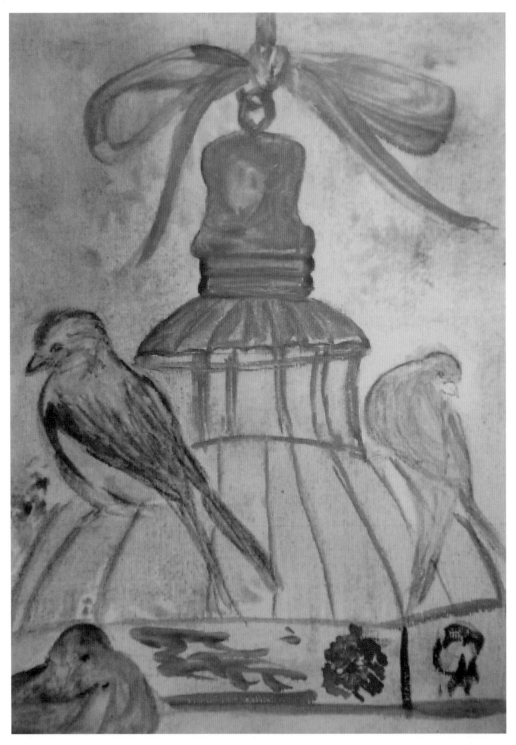

Free at Last by Reyhana

PART ONE

AN IDEA

Still Beating by Shaka

1

WELCOME TO THE NEW ART STUDIO

Making art with the dispossessed

Strong bonds form when people make art together. Intimacy grows swiftly and without effort. And when the people making art are asylum seekers the effect intensifies, as astonishing, unfinished stories unfold on canvas and paper like tales from *One Thousand and One Nights*.

We use the phrase 'asylum seekers' lightly. It rolls off the tongue without thought. We hear it so often that we become immune to the reality of being an asylum seeker unless we are lucky, like me, and get to make art and develop friendships with those who have experienced it. Each of them is an individual with stories to shame the media headlines – the kind we assume happen only in movies and *Boys' Own* adventures full of escape, near-starvation, unjust imprisonment and tyrannical rulers who act with impunity. Stories that make civilian life in the free world seem childlike and unchallenged.

Going Away by Paul

Snowy Mountains by Akram

In the beginning, the lives of asylum seekers were just like ours. Before civil war broke out, before despots took control, their lives were full of comfy normality: school, work, marriages, emotional fall-outs and reconciliations ... before they began to run. Caught in the crossfire, they fled for their lives and are now adrift, globally homeless in an indifferent world.

Buried in the Escher-like labyrinth of the Islington Arts Factory (an arts community centre reminiscent of the heydays of the 1970s) with no natural light, a leaking roof, cold in winter and hot in summer, existing on donated materials, the New Art Studio is a lifeline for people who have nothing: no family, no money, no connections.

Where do we go when we make art? To our unconscious, to our underworld, to places that frighten and compel us. To our dreams and to our nightmares. At the New Art Studio we travel that journey together.

I'd like to introduce you to the people behind the headlines and the statistics. To a group of artists, a group of friends. Let me show you around.

Universal Exile by Paul

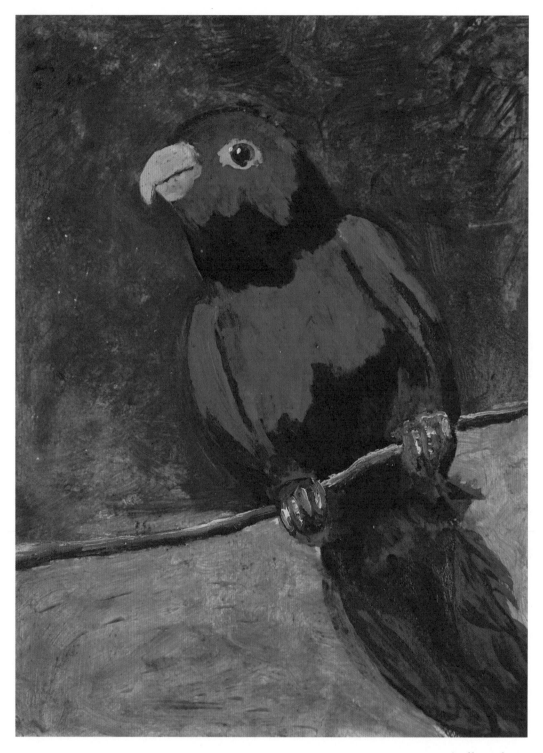

Determined by Reyhana

2

PARK LIFE

The New Art Studio as a refugee

Before the New Art Studio I ran a similar project for six years as part of a large charity. It was here that I met Jon Martyn, a fellow art therapist. It was a thriving project. The clients and I bonded way beyond the boundaries of formal psychotherapy – we bonded as artists and we bonded as people. It was there that Jon and I began thinking and planning what was to become the New Art Studio.

That feeling of connection and camaraderie is vital for refugees and asylum seekers who have had to leave their sense of belonging behind. The studio had an atmosphere of community akin to extended family and it became as important to me as it was for the members who attended. So having to explain that it was closing for reasons beyond my control was devastating. I felt the air being sucked from the room when I shared the news, and watched as everyone readjusted to the new normal as they had so many times before.

The easy thing would have been to find another job, and say goodbye and good luck to the group. But I didn't – I realised I loved that studio and all who sailed in her.

I loved the people who arrived shaken and frail and came back to life in the slow, silent aura that blanketed the studio with love and hope. I loved the use of mixed-up English to describe the paintings, art materials and feelings that accompanied the images. And I loved that all this happened inside the warm glow of art-making.

I had made art with many different 'clients' in the past, but this group held my attention in an otherworldly way. I transcended something with them, crossed borders from their countries to here. So when we were made homeless, refugeed in a cruel mirroring of their own stories, I heard myself promising that, in some form or other, we would continue.

And then we hatched a crazy plan. Until we could find a new space, we would meet once a week in the park. We would recreate the studio we had shared, simply without the walls and ceiling. In a way, this shaky ground was familiar territory. The studio members were – and still are – used to living in hope and in limbo, from one day to the next. Now our little studio was thrown into the same rolling sea. We lived on our wits and wings and prayers.

And art, always the art.

Slowly but surely, rough-and-ready Finsbury Park itself became a facilitator. We would lay out our art material and our food on a blanket, and settle down to our usual Thursday. The group would sit and chat, drawing trees and skies, birds and bicycles. One of the members told stories of sleeping here for two weeks when she had first arrived in the United Kingdom ten years earlier. Lela, one of the longest-standing members of the group, explained which berries you could eat from the trees, trees I had walked past a thousand times before and now saw in a completely new light. Lela's knowledge of foraging came from her years as a freedom fighter, when she became skilled at survival techniques.

The fact that the group was willing to take a chance on me – and each other – without the physical and emotional security of an institution was the beginning of a series of small miracles. Trust issues are a major part of the asylum psyche, so for these people to meet in the park without a receptionist, caretaker, key worker or any other visible trappings of an established charity was in itself a celebration of our vision.

The talk would always return to the future of the studio. 'New studio coming?' I would reassure everyone that 'Yes, there is a new studio coming …'

Shelter by Lela

Edmonton by Anon.

This limbo time made for a very dreamy atmosphere, playful and silly, life lived in the moment. Revelling in that sublime, in-between space where all bets are off, we were babes in the woods, fairies making homes from grass and bark. The girls would go off for strolls, picking herbs and flowers, sharing their riches back at our makeshift HQ. One made a tiny installation of mythical creatures born of twigs and leaves and petals and ferns. Others made rubbings from the bark of trees, enjoying this simple sensory experience, and all the while our one child played hide and seek in the bushy undergrowth. With few paints and papers, nature is and always has been art. Necessity truly was the mother of our creativity.

At the refugee charity we had the luxury of walls where we could display our latest artwork, and spend time looking and reflecting on the day's activity together. In the park, the girl who made the mythical creatures set up her miniature models along a log, so when we had our traditional talking time they were included in our discussion.

The experience of looking at art is very different from that of making it – especially if you are the actual creator. Looking gives time for reflection and separate thought. Unplanned and unexpected conversations would emerge. We had created a sanctuary under the shadows of the summer trees, the birds chirping around us. In many ways our time in the park was idyllic.

During those magical but fraught months, Jon and I pressed on with our quest to find studio space and source funds for rent and basic running costs. We visited community halls, warehouses and cafes – we went anywhere and spoke to anyone who might take this motley crew of dispossessed troubadours. Between us we attempted to will the four walls and a roof into existence.

But as the summer breeze and London's light mood faded, the seriousness of our dilemma came into sharp autumnal relief and, after months of asking 'New studio coming?', the girls began to mock-shiver, saying through chattering teeth, 'Oh, we must love art so much – we even paint in the rain!'

Privately, Jon and I worried our dreams and aspirations might not materialise. But we had made a promise and failing to deliver was not an option for either of us.

Friend or Foe by Shaka

3

'NEW STUDIO COMING?'

How the New Art Studio finally found a home

We continued to congregate in the park. Secretly, silently, Jon and I were very nervous about how our new studio would come into existence, but there was nothing to be done except put one foot in front of the other. And by that I mean cold-calling, cold-emailing and rooting out any vague contact who might be able to help.

And then, at last, something happened.

Some people instinctively understand the studio and the importance of spending the day making art together. One of those kindred spirits, Sally Woolfe, was a counsellor at the refugee charity; as a sweet gesture she would bring us weekly bunches of flowers from her garden. They became a happily anticipated delivery, as regular as milk from the milkman. Virginia Woolf's Mrs Dalloway 'said she would buy the flowers herself', but Sally actually grew hers and chose each bouquet especially for us: roses, bluebells, baby's-breath … her kindness was rewarded with the beautiful name our artists gave her: 'Sally Garden Flower'.

We would study the blossoms, smell them, paint them and dream about them. The scent from the freshly cut flowers would mix with the linseed oil and white spirit as we positioned them in jam jars at the centre of the table for everyone to enjoy and paint. So many different ways of seeing. Flowers would grow from charcoal, from oil bars, from watercolours, and at the end of the

Charcoal Lets Me Begin by Wallid

afternoon I would distribute posies to the girls, who took them back to their rooms as reminders of the day's camaraderie.

The National Asylum Support Service (NASS) rooms to which the artists returned form part of shared hostels on the outskirts of town. These can feel like frightening and unsafe places. People share rooms, bathrooms and kitchens with other asylum seekers who are complete strangers. Sometimes these houses seem more akin to brothels – where there is poverty there will be prostitution. Asylum seekers must sleep there every night. If they break the rules they are threatened with deportation. No wonder a tiny gesture like having flowers to take home takes on profound meaning.

Sally Woolfe would often talk to me about a friend of hers, a psychotherapist and anthropologist, and her work researching shadow puppets in Indonesia. Hers was a creative take on Jung's theories of the shadow as the darker side of our personalities, the place we cut off, bury or run from. I was intrigued and keen to meet her.

And finally I did. Angela Hobart turned out not only to be a psychotherapist and anthropologist but also the founder and a trustee of The Sutasoma Trust, a small fund that helps art-related charities. We had an instant rapport. Though older than me, she has a youthful, creative sensibility. She also taught at University College London, and invited me to talk at a conference about the psychological effects of torture and how art can play a part in the healing process. During the conference we held a small art exhibition in UCL's grand foyer. *Act as if. Act as if we would get a studio* …

After weeks of meetings and proposals the trust agreed to fund two salaries, one day a week, to get the studio off the ground. Jon and I were as excited as we were relieved. We were on the road at last to creating our own little project. All we needed now was a space, a room of our own.

The conference helped us make many connections. A fellow speaker was the CEO of another prestigious refugee charity. He liked the sound of the studio and offered us a room.

Bingo, let's go!

It was now September.

Sunlight by Akram

Euphoria, jubilation, give thanks and praises, we were saved from a winter in the park!

But things were just too good to be true ... We didn't really fit the charity's profile and they didn't fit ours. Within three short months we were asked to find more appropriate premises, a place to make art, a place to get messy. The fear of mess has followed me throughout my career as an art therapist. I've always known life is nothing but messy.

So yet again we were back to the drawing board. Back to square one. But please God not back to the park.

And then Jon's father reminded us about an art group Jon had taught many years previously at the Islington Arts Factory. He suggested we try there. We gave them a call. We saw the space. And we were home, in a large, messy art studio, within an arts community. A group sigh was sighed.

Except that we couldn't quite pay the very reasonable rent. In this digital world where everyone is simultaneously connected and disconnected by social media, we put up a JustGiving page and ... it worked. I have never liked the idea of asking friends and associates to fund my passion – especially when that passion is arguably something that our government should provide in order to protect its most vulnerable – but needs must and we raised funds to pay the rent for a year.

Most of us take our sense of belonging for granted. We don't have to worry about being deported, we don't suffer flashbacks and alienation, so it's hard to understand the way in which refugees internalise their sense of home. The rooms they frequent are not homely; the Home Office to register their existence, a solicitor's office – at best a charity for refugees. When there is no more physical home, it has to be located inside the body.

The struggle to find a permanent studio for these courageous souls was an adventure fuelled by sheer energy, determination and love.

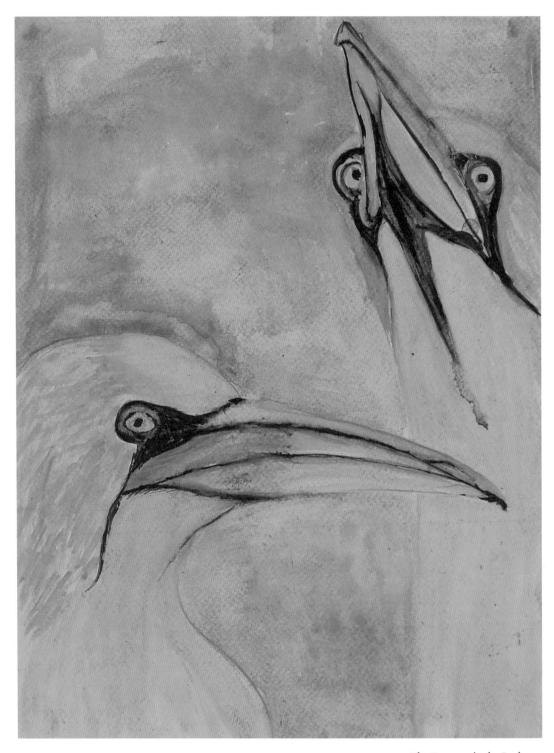

The Conversation by Reyhana

4

POLITICS AND PAINTS

Daily life in the studio and the vital part it plays in members' lives

Making art is an extraordinary process.

An object that wasn't there before – a statement, a mark of existence like the handprints on the caves at Lascaux – now exists. The need to say 'I am' is ever-pressing.

At the New Art Studio something very particular is laid bare on the paper. Something that makes the studio a very unusual and inspiring place. What we see, what Jon and I midwife, is the effect of war and political tyranny. Every image made here contains a history of terror; of injustice; of humankind at its most unkind. The worst of what we are.

Sometimes the work reflects this darkness directly. But, more often than you might imagine, it moves to a fantasy location, both physical and metaphysical, where good conquers all. We wander through beatific mountain scenes and forests, walk alongside lakes and oceans. There is a sense of dreamy pastoral where the dreary daily life of asylum existence is suspended. And as we watch, the artists standing at their easels move into their paintings like stepping into a stage set – or, like Alice, through the looking glass.

At other times we see mercurial, expressive abstractions, where members of the studio start to explore with materials. They crush charcoal, pour inks, and use sponges and knives to conceal and then reveal, pushing the abstraction to its celestial

Inside the Storm by Eva

extremes. This is pure, raw emotion. And sometimes we see social commentary posters incorporating African graphics, or Russian space pods seen from naval ships in the Caspian Sea.

All the marks on the paper are made in the context of asylum living and what that means to an individual. When everything's been taken – home, family, safety – and you are homeless in the world, imagination is the only place of true freedom and solace.

The artwork is as individual as the makers' dreams and nightmares.

Trust is a relentless shadow that haunts all members of the studio, so the loyalty and camaraderie that exists in the room takes on a beautiful glow. Just the ability to connect with each other, to share their images, their darkest moments and small victories, transcends the bureaucracy that overshadows their lives. Spoken and unspoken acknowledgements of loss and present day frustrations are with us throughout the day. Mutual encouragement from others who've been in the same boat means more than any professional could offer.

Some of our artists have never made art before and they often speak of their world opening up, with new ways of seeing and being, expressing and processing – all this within the safety of our little studio.

Some members have been professional artists in their own countries. They effortlessly guide curious newcomers through this world of crayons, pastels, oil bars, oil paint, charcoal and graphite pencils. One very skilled watercolourist helps those keen to learn about tone, shadow and light.

There are no formal lessons, no them and us. That's the magic of this art therapy model. Jon and I make art alongside studio members, meeting as artists. We eat together from a rolling buffet in a less paint-splattered quarter of the room. We're in it together for the long, internal journey: creating, restoring and enjoying this band of people making art, making tea, making jokes and making friends. Often I think about the forces that join all these beautiful individuals, the horrors they have survived and the fears they still live with, totally at the mercy of government decisions.

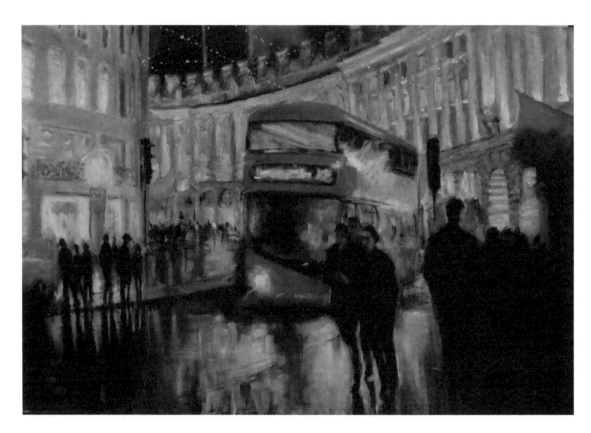

City Lights by Benjamin Croft

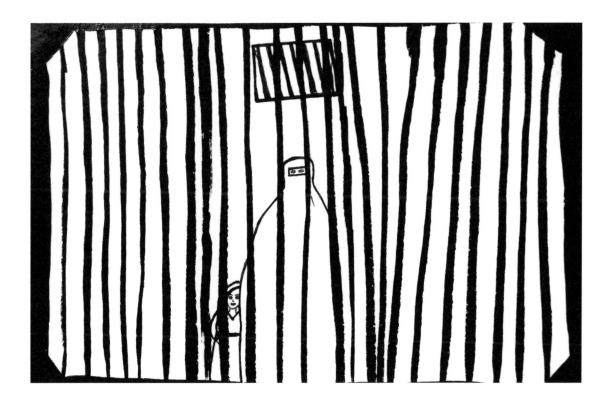

Generations Behind Bars by Anon.

Whether a Russian or an Iranian or anyone else will gain asylum and become a refugee (a much better and safer position) depends on the diplomatic relationships existing at that particular moment. If the British government needs to keep favour with a particular regime, it doesn't look good to accept people fleeing that regime. It's as clear as saying 'We have to take your folk in because you're so terrible.' And thus victims of war, political unrest, civil conflict and international espionage become victims of a global political and administrative nightmare.

Decisions made around oval tables in faraway bunkers trickle down like treacle into our hideaway studio. It's not uncommon to wait up to ten years for a case to be cleared and refugee status given. In the meantime you are not allowed to work and have to live on less than £40 a week – effectively enforced poverty in an open prison for ten years and more.

Imagine coming to paint under those circumstances! The members openly talk of studio attachment, studio love, 'studio saved my life', 'studio is my life', in a combination of pidgin English and an array of different languages including Russian, Farsi and Turkish. But art plays with language, gives language the passenger seat. Art surpasses language. On studio days it is the paints and brushes and crayons and canvases that are given free rein.

No one plans to be an asylum seeker. It's never a choice. All our artists have found themselves adrift in the world, and found themselves again in the art.

It's always in the art.

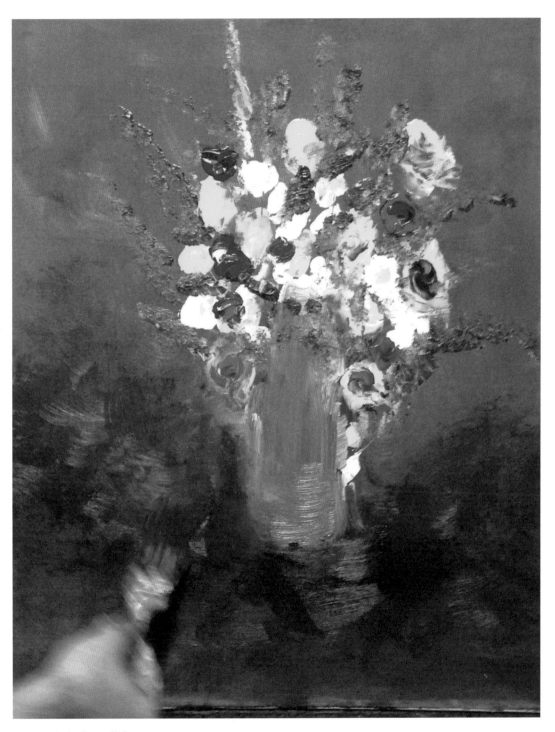

Action Painting by Wallid

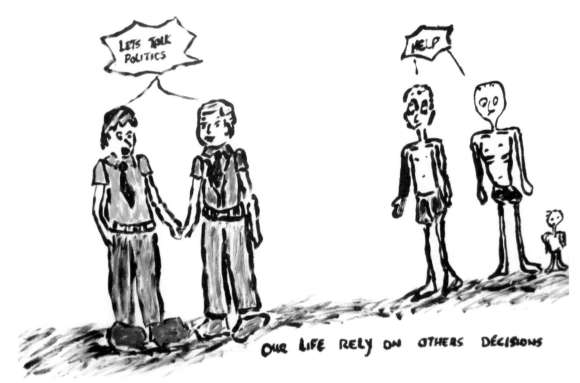

Let's Talk Politics by Paul

PART TWO

STUDIO STORIES

Cracked City by Shaka

5

SIRI THE SAVIOUR

Before you get to the studio, you've got to get through the night

Some stories can't be told. They remain within the archive of our memory, locked safe and guarded. Some can't be told because we are ashamed. Often for asylum seekers, it's because they fear violent retribution and repercussions. While their stories are 'cases' for lawyers, they are complex and highly confidential matters of life and death for the asylum seekers themselves.

I am thinking of one very isolated woman, Shaka, whose crime was not to cross a forbidden boundary, or take part in a heinous murder, or traffic huge quantities of drugs: her 'crime' was to have a boyfriend here in the United Kingdom. The tentacles of gender apartheid stretch far and wide, so I can't share her story fully without risking her safety. But perhaps I can tell a story about that story.

Most members of the studio seek asylum because their country is unsafe to live in, and they come to the UK to escape war and human rights violations. But some members seek asylum from inside the UK. They may have arrived on bona fide work or student visas but their activities here – in this case having a boyfriend – mean they cannot safely return home. 'Honour killings' are a real threat as families disown their own daughters in order to 'restore' their good name.

People in this situation experience life in the UK in two very different ways. First they enjoy a privileged, civilian life on a work visa, with all the freedoms that brings. Then comes the dramatic

Maze by Shaka

contrast of being thrown into NASS housing, not being allowed to work, and living with the sudden threat of detention or deportation. These polarised existences can badly damage a person's sense of who they are, as their identity is now dictated through the eyes of others.

Shaka lives alone in NASS accommodation. She hardly eats, she rarely sleeps, and she draws patterns like the mazes asylum seekers exist within. She makes clothes, paints her nails yet again and waits for the sun to rise, hoping it will surprise her with good news. 'Good news?' is a familiar phrase at the studio. It is what every asylum seeker waits for.

One particular night, Shaka told us, she was desperate. She felt alone and afraid. The group listened. 'What did you do?' someone asked. I found myself hoping she had perhaps called The Samaritans, but no, she had opted for digital help. She had called Apple's virtual assistant Siri. She explained that she was suicidal because she felt so alone. He – her Siri had a male voice – reassured her, saying, 'Don't worry, you're not alone, you have Siri.'

The group responded warmly. 'Ah, bless.' 'That's sooo nice.' Lots of satisfied noises. A general sense of feeling a bit better. And I thought about how digital the backdrop of the twenty-first century has become, how it has seeped into our core, our essence; and how initially it was alien, but we learned to adjust and incorporate this new way of communicating. And as the asylum seekers I have come to know adjust to life in the UK, so I have had to adjust to this. For many people over 40, having an obviously non-human interaction at that desperate moment might have pushed us further into existential crisis. But this group is formed of a younger generation. Everyone was on board with the Siri story where, through the darkness of the small hours, a virtual assistant picked up the baton until daybreak.

Once in the studio, art holds and shrinks the terrors. Shaka paints owls and clocks and repetitive patterns that reflect and vent her frustrations, until she goes back to the NASS place and leans on Siri once again.

In truth, of course, it doesn't matter how you get through those nights. It only matters that you do.

Still Awake by Shaka

Sleep Denied by Shaka

Night Terror by Shaka

Cemetery Maze and *No Exit* by Shaka

No Way Out by Shaka

Bat in the Night by Shaka

DNA Destiny by Shaka

Problems Are Like Ghosts by Shaka

Pushing Through by Eva

6

THE BODY REMEMBERS

How the memory of trauma remains in the flesh

The mind thinks it is too clever for the body. It thinks it can forget in an organised fashion. It decides: 'That isn't a good memory, I will shelve it, close the door on it, put it to sleep.'

It sounds like a good idea, sounds simple, sounds logical. But it isn't always that easy. The body has deeper memory, a visceral oily recall that slips and slides and won't be told. The place of trauma, the flesh, the cells, think differently. Wounds may heal on the surface, but the damage is deep and internal.

In many countries, women are currency used for bartering, exchange and family legacy. From birth, women are owned. They are bought and sold at the will of their 'owner'. Not only at the obvious sex markets where girls' teeth are checked like horses', but in everyday life, often in subtler ways. This abuse goes deeper than the laws that stop women voting or driving, or leaving the house alone. It lives on in the body. As one member of the New Art Studio explained in simple terms – holding her palm a few edges above the floor – 'Girl is nothing.'

So from the moment of birth, a girl knows deep down that she may exist in her body, but it is not hers. She carries it around for the use of others. She cannot say no to an arranged marriage to a man she has never met who is old enough to be her grandfather. She cannot say no to the knife that will slice between her legs. She cannot say no to anyone who may want to 'have' or 'take' her.

I Still Want to Live by Eva

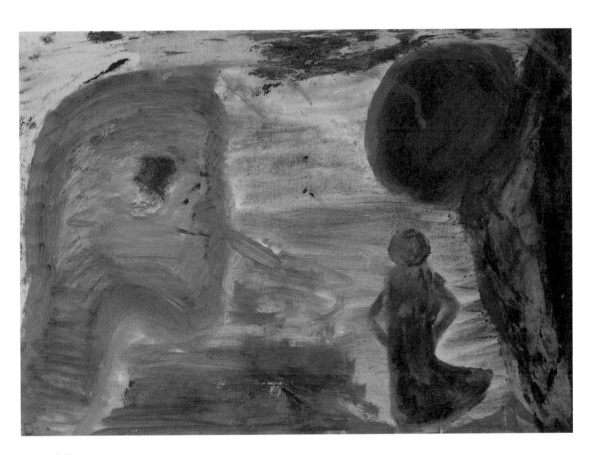

Be Careful by Eva

On so many occasions she may have to disown her own flesh, remove herself from the experience, go somewhere else in her mind – somewhere over the rainbow.

But the residue of experience remains in the flesh. The women at the New Art Studio may be in their twenties, but they suffer complaints that we associate with the elderly: arthritis, back pain, nerve pain, eye floaters and loss of hearing. Many have been raped. It is as common as starting your period; it is a rite of passage. It could be your brother, your brother's friends, a soldier 'helping you' by trading free passage or documentation for sex. Or it could be a merchant who bought you like a goat.

Can art heal this too? Go this deep? One young woman – so heavily medicated that her face would lie on the paper she was painting – moved her brush in a lethargic half-sleep, eyelids closing, her black hair sticky with paint. Eva's chosen palette was red in all its hues: purple, wine burgundy, violet, pink. She painted from the inside out, slowly sliding her thick brush across the page, painting her womb. Inside outside. Academics call it the unconscious. I call it the flesh.

Her abstractions had their own reasons, their own motivations. Sometimes making angry strokes, always freeform, always penetrating the page with bloody shapes that gushed without boundaries, that knew no beginning or end. That knew no 'NO'.

When Eva had finished and actually fallen asleep – face-down, eyes closed – she rested. After the rest she pulled her face away from the table, untangled her hair and looked with surprise on the work she had created. Separated from her, disowned like her body. Often she would say 'It's not a picture – that's a picture,' as she pointed to an accomplished studio member's work showing images that were recognisable: people and trees and buildings and places. Things that can be named and contained by language.

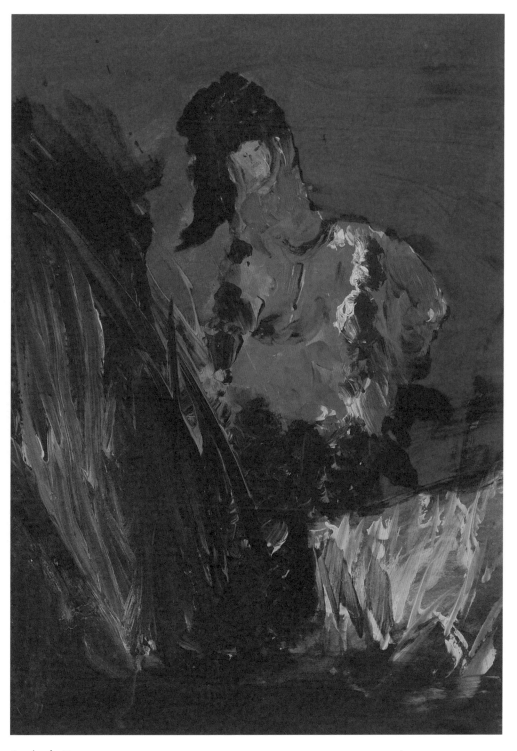

Survivor by Eva

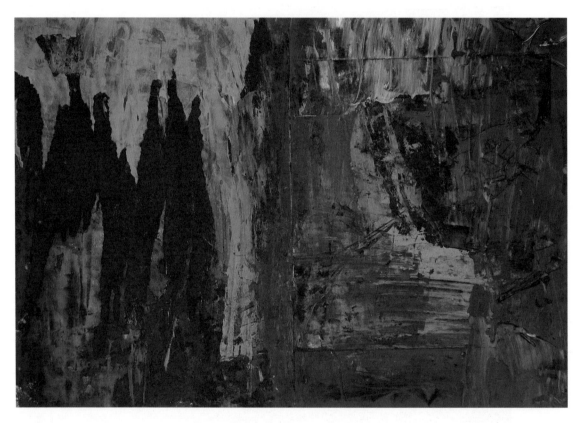

Abstract Feeling by Eva

I explained abstraction; I showed her Rothko, Kandinsky, Cy Twombly and other artists who had also abandoned nameable objects and instead allowed feelings to hold the reins.

At last, after many years and less medication, she sat up straight and awake and ready to paint. Now when people in the group ask about her painting, she says proudly: 'It's my feeling.'

After making art for over ten years, first at the refugee charity and now at the New Art Studio, Eva finally owns her trauma. She can contain the free-flowing anxiety and depression that used to suffocate her. Her nightmares have become 'good nightmares' where she fights and beats her attacker. She has come alive and does voluntary work in charity shops and at a hospital where she is full of empathy and compassion for others. She is a true wounded healer.

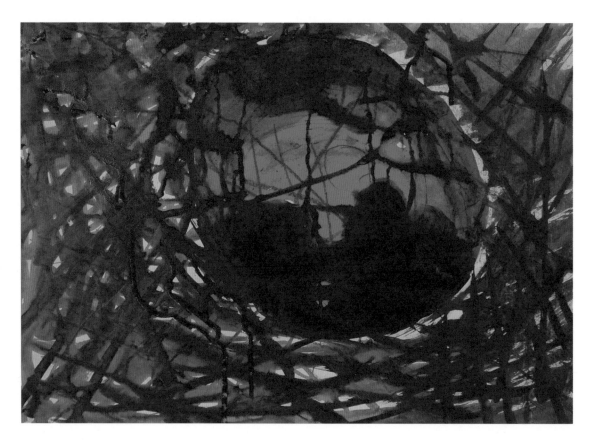

Boundary and Protection by Eva

Lovely Romance, Confusion in My Mind by Eva

Stop by Eva

Dark Conversation by Eva

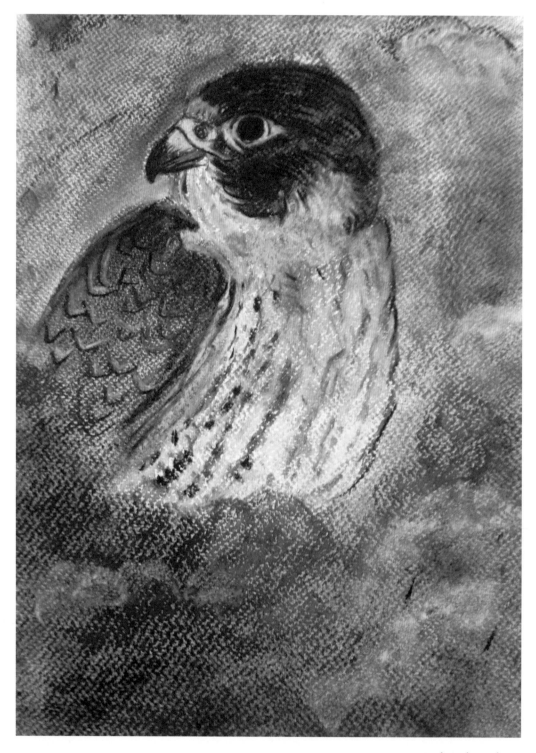

Eagle Eye by Reyhana

7

THE BANALITY OF BUREAUCRACY

The process of seeking asylum can often take up to ten years

Reyhana paints mostly birds. Green bee-eaters, sparrows, parrots, vultures feeding their young in nests, inside and outside golden cages, in flight ... they are usually solitary, apart from the offspring.

Reyhana has raised a son in her NASS room. The boy is now 9 and has been with us since our days as part of the large charity and since our days in the park. Reyhana's is a state-endorsed hostage situation. The boy goes to school, diligently. She comes to the studio, diligently. But there's a short lead around her neck.

NASS rooms are all the boy knows. Education is his passport and she tutors, reads, tests and disciplines him every evening. Inside the walls of her cubic pod she is militarily focused, taking no prisoners and no nonsense. Her fortitude is their survival.

In turn, her little boy is a delight. He is polite, intelligent, fearless and, as the cliché goes, a credit to her. He is a member of the New Art Studio family. We met when he was 2 and he has been part of the studio's journey. We've grown up together. He comes to exhibitions, events, launches, Christmas parties. He makes art – mostly volcanoes – in the studio with us.

Way back when the studio was officially homeless and before we started painting in the park, we would congregate in cafes and people would bring blankets, food and art materials. One day

Still Waiting by Reyhana

the pound shop across the road caught the boy's eye and a few of his studio 'aunties' took him to buy a little treat. They came back triumphant and ironic (much-needed humour has always played a big part in our therapeutic work). The boy had chosen a Korean-made set of prisoner and guard props: plastic handcuffs, a baton, even a Disneyesque key. Everyone recognised the instruments of captivity, but this time everyone present was robust enough to engage. Like all children, he needed to play out his reality. To reconstruct his reality.

Reyhana has appealed her asylum rejection and been turned down twice. She was a professional at home and is now gagged and chomping at the bit. Her dream is to work, to engage, to interact, to contribute. She is anything but a slacker.

After weeks, months, years of limbo-living, Reyhana was collecting paperwork for her solicitor to make a fresh claim. It is arduous, pedantic work and requires internet access. There is no internet access in her NASS building so she set off with her son to her sister's house, taking two buses to get there. She worked conscientiously, late into the evening. The young boy got tired so they stayed over with her sister and her family for one night, and then another.

When Reyhana and her son returned to their NASS room it was locked and she wasn't able to enter. Housing officers had carried out spot-checks and she had broken the NASS contract that specifies that you must spend every night in your room. She would need to re-apply for accommodation, but for the time being she was officially homeless. Weeks of Kafkaesque administration and anxiety ensued and Reyhana had to travel miles to get her son to school each day.

Eventually their original room was reinstated.

These rooms, where people live like prisoners, are all around us. Their inhabitants can't leave the country. They have no documentation to travel. They can barely step outside the door. You have to be a tough bird to fly above that.

Finally Reyhana arrived at the studio with 'Good news!' She had been told by her solicitor to take her paperwork and file to the Home Office – in person. No posting, faxing or emailing was permitted. The only problem was that the specified office is in

Liverpool. When the group heard this they wondered aloud if it was, in fact, 'good news' after all.

'I know someone who went to Liverpool, that's a good sign.' Everyone at the studio was drawn into the game of guessing and speculation, myself and Jon included.

The system is so complicated, so slow, so tied up in bright red tape that it's impossible to know what the requests in the run-up to a court hearing actually mean. Someone asked if she was told to bring a photo, because that means something too.

She was not.

Let's stop for a moment and consider this court case. Reyhana's life depended on it. She wasn't concerned with the usual court decision – innocent, guilty, time behind bars. She feared for her life. Some hearings result in the subject being returned to a country where they will most likely be killed. But Reyhana had prepared herself for the very worst. Because sometimes living in suspended time on less than £40 a week is worse than getting bad news.

She was required to be at the office in Liverpool at 1 p.m., so the first challenge was how to get her son to school and travel that distance on her meagre allowance. Her sister could take the boy to school – first problem solved. And she would take the cheerfully cheap Megabus from London to Liverpool. But. There is always a but. The bus is slow, and the morning departure wouldn't get there on time.

When she explained to me that she would go the day before, I naively asked if she had people to stay with in Liverpool. No, of course she didn't. She would take the midnight Megabus and arrive in the early hours on the following morning ready for her 1 p.m. appointment. And this is 'good news'.

Imagine how it feels to arrive at an extremely important appointment – one that literally signifies life or death – after being on a bus all night and arriving in a city you have no clue about.

I can see her clearly. Steely, focused, hair tied back and beautifully presented as always, clutching her documents close to her heart as she navigates her way around Liverpool city centre. Counting her pennies for a coffee in the station.

It sounds like a Beatles song, but it is not.

Soft Landing by Reyhana

Sad Glamour by Reyhana

Still Hidden by Reyhana

Taking Care by Reyhana

Stay Away by Reyhana

Charcoal Woman by Reyhana

And There is Darkness by Wallid

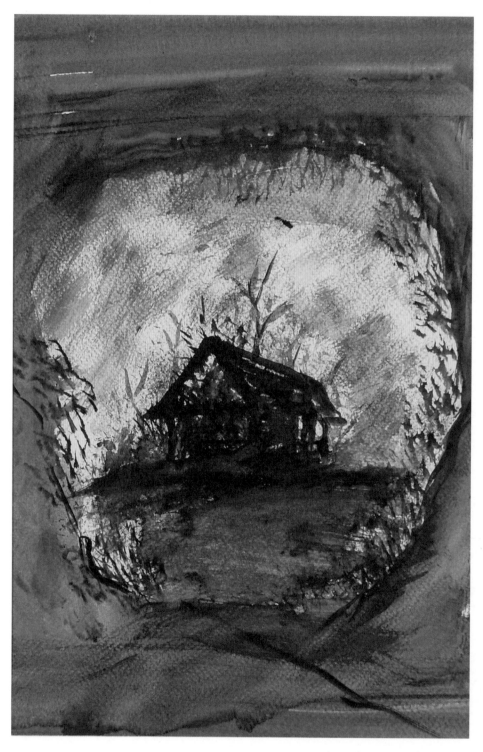

Charcoal Keeps Me Safe by Wallid

8

'WALLID, YOU'RE NEXT'

Living with the constant threat of the detention centre

I met Wallid ten years ago, back at the big refugee charity. He was a frail, frightened 19-year-old who suffered from migraines and epilepsy. He spoke in a whisper, cautious of his own voice. He had a look that was a thousand-mile stare into the abyss, wide-eyed and terrified. He had never made art before, had no cultural reference to art-making and had barely finished primary school.

His memory of his hometown was dim, shrouded in mist with flickers of memory ... like the day the soldiers stopped cricket in the street and in the playground. Slowly, like the journey he had taken, his story unfolded as he painted. Memories returned and he shared vignettes of his experience with the group. They often emerged as multi-subject sentences: 'I fell from the horse, the snow was deep, I lost my shoe but the people were nice.' 'I went into a small house with others, they thought I was a boy but I was sixteen.' I didn't want my desire for clarity to break his flow, so I would let him talk without asking questions.

Wallid began by making black marks, scratching into the paper. He drew on scraps, polystyrene cups – in fact, any material that he could find. And then I introduced him to charcoal and the memories began to pour out: isolated farmhouses with a particular, dim light that meant so much, huge landscapes, mountains, trees and valleys, devoid of people. His images were filmic, atmospheric, haunting.

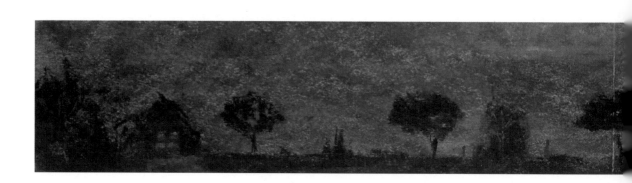

My Long Walk by Wallid

Early Marks by Wallid

The Journey Continues by Wallid

He had travelled many, many miles overland. Horses, carts and motor vehicles featured, but mostly he relied on his legs to carry him to the UK. He lost his parents during the journey and arrived alone, thinking he might be in Italy because he had once seen a film set there and the immigration officer looked like a character from the film.

In London Wallid moved in with an uncle. He was still officially a minor and didn't need to sign at the home office as adult asylum seekers do, but while he was hospitalised with seizures he turned 18 and his claim became increasingly complicated. His uncle convinced Wallid to live below the radar, not to seek asylum but to work in his kebab shop. And so he did ... for over ten years.

In life this young man is timid, fearful and extremely suspicious of everyone. In art he comes alive, master of his own fate, king of his canvas kingdom. Moving from charcoal to oil paint, from polystyrene cups to canvas, he now attacks the page, adding and subtracting material, tissue paper, crayon shavings, thick oil paint applied with sponges, wiped away and then added anew. He paints landscapes from Arabian tales, rivers, streams and cool breezes – truly soulful works full of the hum and zing of loss. Undisturbed by historical reference, he is without context. He hadn't heard of Turner, of Anselm Keifer, of Rothko, and yet he followed in their footsteps.

Wallid still works in his uncle's kebab shop six days a week and on the seventh, his only day of rest, he comes to the studio. Could art be God? I sometimes think it might be. Wallid dutifully fasts on Ramadan. He arrives at the studio pale and yellow, his voice muffled from lack of water, but still he comes and he paints because he has discovered a new, unwritten language and code for living. It has no script or scripture; it is internal and ethereal. He is discovering other artists, people he never knew existed, people like himself.

Solid Air by Wallid

Wallid has been detained twice, and held ready for deportation. In a holding room near the airport, he was taunted by guards: 'Look at that plane – you're next ...'

But miracles do happen. Chances appear out of nowhere, lawyers find bits of documentation that change a life in a cracked minute. Asylum seekers' worlds spin on a pin head, so fragile and seemingly arbitrary; the only words that makes sense are 'God willing.' For Wallid, something or someone seems to have intervened – God or art has so far saved him from deportation and silent psychosis.

So next time you or I are in a fast-food place, and the man serving seems polite enough but is slow to talk and sticks to one-word answers, we might choose to take a moment and wonder what else he might do. Perhaps he writes. Perhaps he paints. Perhaps he has found a way to create out of his own particular nightmare. Perhaps he, too, is Wallid.

Slim Hope by Wallid

Tired, Another Long Day by Wallid

What Will Be There? by Wallid

Let the Moon Guide Me by Wallid

A Ray of Light by Wallid

So Many Days by Wallid

Dawn and Dusk by Wallid

The Other Side by Wallid

I Saw Many Things by Wallid

Inside My Heart Is Grey by Wallid

Who's Watching Me? by Wallid

A Bit Better by Wallid

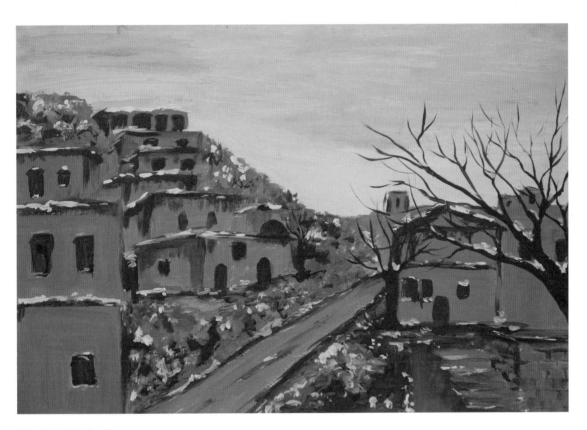

Abandoned City by Akram

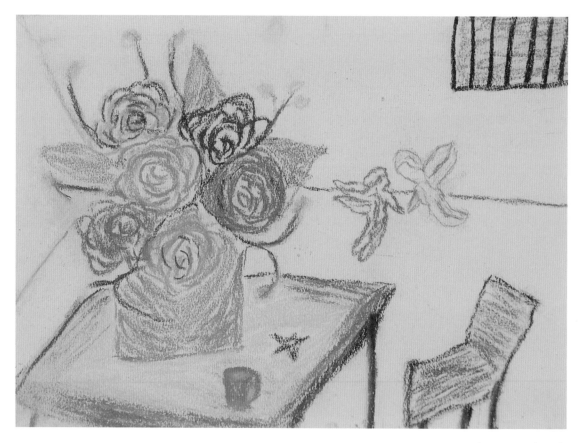

My Angels Protect Me by Lela

THE COAT

The profound camaraderie of the studio

'I never no come.'

Which means I'll be coming back, I'm just dropping off bags laden with fresh fruits, walnuts, apricots and dates … 'No problem, my brother-in-law cousins has market, no problem. I go, I come back, take it, take it. Here, I wash for you.'

I've known Lela for over ten years. She's always rushing from one local errand to another, visiting someone's sick mother or collecting clothes for people in Calais. She's one of the oldest members of the New Art Studio, but still claims 'Me no artist, but I love the studio …'

Lela is so much more than her bags of fruits. She joined the freedom fighters when she was 14 – or they joined her. She spent the next fourteen years fighting in Syria, Iraq and Turkey for an independent Kurdish state. Her commitment is tightly tied up with her childhood and the unit is her family. She didn't see her birth parents for those fourteen years.

When we held weekly art sessions in the park before we found our studio, Lela would bring food and blankets, and pick herbs and berries from bushes I'd previously ignored. She would forage without calling it foraging – for her, it was innate mountain-girl survival. She can shoot, milk goats and make shelters. She has survived in deserts and mountains, walked miles eating what she could kill or find. She has herbal recipes for everything from period pains to torn ligaments. This is no Bear Grylls TV entertainment. Lela is the real deal.

My Wish by Lela

Let Me GO by Lela

With her guerrilla-girl history of surviving in small units, fed on intense togetherness as they battled against extreme cold and lack of food, the camaraderie Lela brings to the studio is priceless. And as her band of rebels is fiercely feminist, she brings extra strength to the suffering women at the New Art Studio.

These days Lela is a cleaner and general handywoman. She is tiny and very strong. Lela isn't fazed by things that would be a problem for you or me. But, as her English is still very broken and her formal education stopped when she joined the freedom fighters, her problems revolve around things like trying to navigate a phone call with the council to explain the leak in her bathroom. These bureaucratic hurdles frustrate and confuse her. The formal language they use makes her feel belittled.

Despite her own challenges, Lela welcomes new members with warmth, openness and connection. It is always a pleasure watching her greet new people. She is like a tribal chief, with expressions and gestures that melt hearts. 'Don't worry, it will be better ... come, sit, what is your name, eat, what do you like?' Perhaps this is what it's like inside a freedom fighter's tent, welcoming a new comrade to the cause. Lela is the captain, and happier looking out for others: a universal mother who has no children of her own. She never – outwardly – regrets sacrificing her life for her cause. Wrapped in her 'Welcome, welcome, welcome', we are safe in Lela's giving hands. What Lela struggles with is allowing herself to receive.

The studio is dependent on the generosity of others and receives all kinds of help from volunteers offering things like classes in English, yoga and life drawing. Sometimes people donate useful items like pots and pans, shampoos, soaps, shirts, duvets, sheets, dresses, boots, make-up ... the stuff of life. One especially cold winter, our generous supporters donated a coat.

A long, down, knee-length puffer coat.

As everyone congregated around the table of goodies, women tried on boots and the coat. We never allocate any item and people never, ever fight for things. The members of the studio are impoverished, humble and proud. If someone is interested in something in particular, they ask the group 'Can I take this?' 'Do you need bowls?' Distribution can take all day.

Make Friends with the Monster by Lela

At Home in the Mountains by Lela

Choose Me by Lela

What's My Future? by Lela

All the women tried this particular coat for size, and like Joseph's coat of many colours it took on magical powers and fitted everyone – tall, short, slim, broad; it made no difference.

Finally a new member tried it and it seemed to stick and the coat was hers. Lela had been a close second but she couldn't bring herself to grapple. 'No, no, you take it. No problem, I have many coats, no problem.'

Afterwards I regretted not intervening. Lela has given thousands of bags of fruit to the studio but so much more too. She has supported everyone through all the years I've known her. And after all that she's done, all that she's given, she didn't get the coat.

But I couldn't ask the new member to return it. It was a done deal. I went home with the image of the coat in my head.

The following week the studio members arrived and another painting day began. People made tea, set up easels, gathered art materials and the studio progressed as usual. Towards the end of the day I remember looking up as Lela stood to go. I looked twice. She was wearing the coat. I had to ask.

The new member had arrived with the coat in a bag and given it directly to Lela. Something in the ether must have told her the coat belonged elsewhere. And for once Lela had accepted.

After so many years of working together, the studio members still have the power to knock me sideways with their generosity and mutual support.

The New Art Studio is for all people. Some stay for years, some move on swiftly to courses in childcare, graphic design, illustration, translation, but Lela stays ... as much for the others as herself. She is the small, strong backbone of the studio. Her paintings are of villages and of women alone, sometimes lonely, sometimes determined. A woman watches on as lovers kiss, or a pregnant woman stares out to sea. Lela's lack of artistic education – or any education apart from learning how to stay alive – allows her to draw and paint bare and honest, from the heart.

And she shows how, when you ignite the fire of camaraderie, it spreads.

Africa Trouble by Paul

COME BACK

Struggling with identity

Paul is an artist. He struggles, however, to see his own worth. Paul received his refugee status many years ago, but this – seemingly the holy grail – proved to be the start of another difficult story.

Paul grew up amid tribal enmities and family vendettas, voodoo spirits and unexplained events that led to children being blamed, cursed and sold. His stories are of wild animals and terrifyingly cruel punishments seemingly dreamt up in another world.

After escaping an ongoing feud, Paul walked and walked. He has been homeless across the continent of Africa, sleeping under panoramic skies, fleeing danger and surviving against the odds on numerous occasions.

When Paul arrived at the studio he would pore over the newspapers, saying – more to himself than the group – 'It's terrible,' and shaking his head as he turned each page of relentless bad news. His eyes couldn't help stopping at disaster stories of human tragedy, fear, intimidation, gang warfare, rape, incest. He would read these horror stories aloud. They resonated with his past. He had internalised his terror and these daily tragedies mirrored his own fears and experiences, past and present.

Maybe by reading the daily horrors Paul reassured himself that he wasn't alone? That his paranoia was indeed grounded?

World on Fire by Paul

LA Vampires by Paul

Paul's pictures are profound, witty, full of poetry and meaning. They often incorporate text into the image. They are graphic in style, with the kind of clear, bold lines often seen in 1950s civic instruction posters. His pictures are social commentaries, catching the zeitgeist. But he sees beyond the headlines. And like a subversively honest adman, he tells it like it really is.

In *Crying Teddy*, a teddy bear cradles a human, suggesting a power reversal. In *Exile*, a godlike figure points and directs a line of people walking solemnly away, with no explanation as to where they are being sent. In *White King*, a puppet jack-in-the-box is adorned with gold chains and jewels. *Who Am I?* addresses the philosophical struggles with identity that dominate contemporary thought – and gives this book its name.

The distinctive, provocative declarations incorporated into Paul's work often suggest imperial power or power dynamics in the caring professions. But, despite his bold style of line and graphic representation, the effect is to leave the viewer guessing or questioning. Paul's use of language and his style of artwork remind me of Jean-Michel Basquiat. I often have fantasies of an advertising company or a graphic design company offering him work, but the chances are slim. It feels as though he comes from and still exists in another world and another time.

Paul's arresting images remain unknown to his customers. After getting his refugee status he spent long hours working in a supermarket freezer department before finally being promoted to the till. While he worked, he studied hard, topping up his engineering degree with qualifications as a plumber. He told us about his surprise and disappointment at the devil-may-care attitude of his younger peers, who would text each other throughout the class and smoke weed during the lunch breaks.

Intelligent, capable, practical and religiously honest, working hard and respecting authority, Paul still struggles to find secure, full-time employment. We see him less and less, as he juggles his zero-hours contract as a plumber and his weekends on the till.

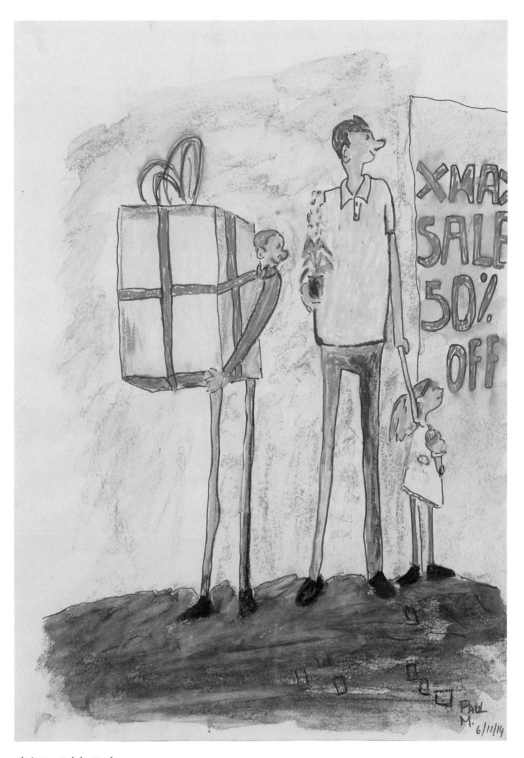

Christmas Sale by Paul

He doesn't have the privilege of connections, of friends made at school and university, family friends, someone to put in a good word for him. Sadly, he appears to have internalised the racism that still restricts the path to financial success. He says people don't understand him, his accent. This is both his and their loss.

Paul's is the kind of immigrant story I see and hear repeatedly. Never mind how highly educated you are, the destructive combination of internalised inadequacies and external barriers conspire to prevent a gifted and talented artist and tradesman like this from achieving. All the people at the studio face this disadvantage. They are disconnected from their original contacts and too shy, too mistrusting or too alone to develop connections with people who could help.

Paul's solace doesn't come from his professional or academic achievements, or from his artistic developments, but from his local church. The church has kept him sane. He prays a lot and the congregation always offers him kindness and a sense of community. It also offers acceptance. But sometimes this level of acceptance can limit a person. Acceptance of working at the cash till, acceptance of working in the freezer section, acceptance of a zero-hour contract – it's a fine line between accepting your limitations and abandoning your potential.

The reality of this accepting attitude, of Paul's lack of confidence, lack of agency or sense of entitlement, means he can't find the time to travel two hours each way to come to the studio. He can't find the time to continue exploring the headline news in bold, bright colours and script.

I want to shout out loud, 'Come back, Paul!' We miss your insight, your humour and your unique, heartfelt declarations with their brave and provocative perspective on the daily headlines. Come back, noblest and most deserving of artists, and claim your identity.

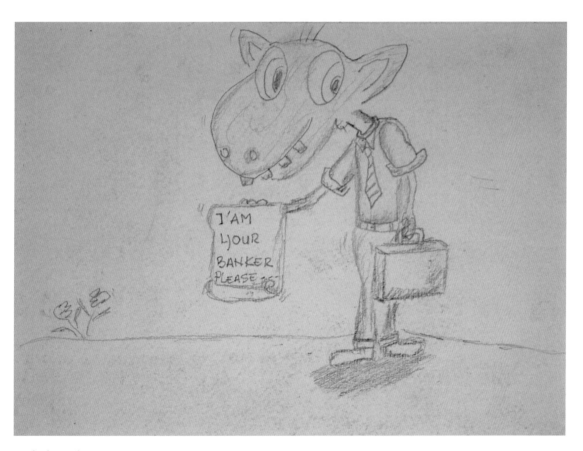

Banker by Paul

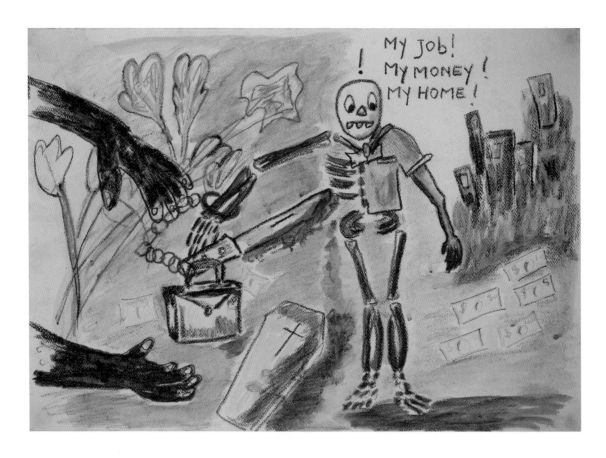

My Job! My Money! My Home! by Paul

Why Fight? by Paul

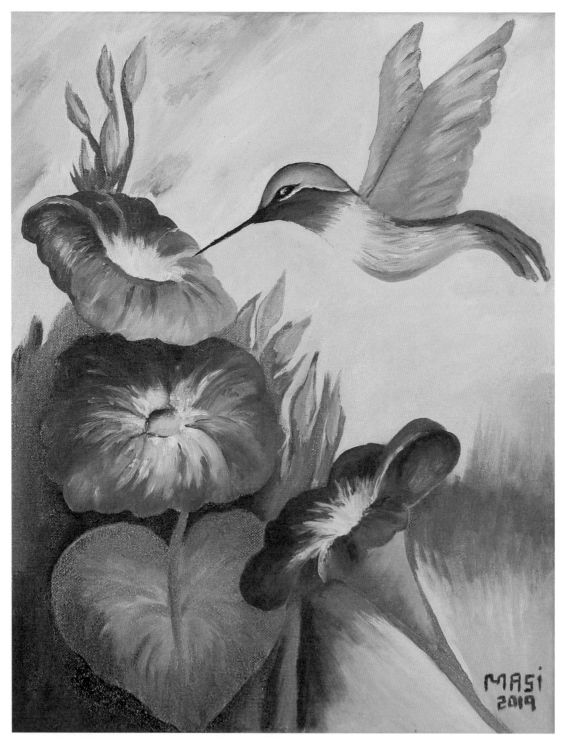

Humming Moments by Masi

SAME PAINTS, DIFFERENT PICTURE

A tale of two pregnancies

It is May 2019 and while one very public royal pregnancy plays out in the media, we have our own new arrival to look forward to. Both our Masi and the royal duchess wait in their suspended pregnancy time, both due to give birth on the same day of the same year in the same city.

Masi arrives at the studio pregnant. We meet her and her embryo together. We witness her shape and form change from the slight curve in her belly to full term, creating a new person who seems not so much inside her as already strapped to her outside.

Masi has been in the UK for some years. She has her refugee status, her language skills and her middle-class education, enabling her to work as a translator.

Life is better for her than for some. Not as good as the royal duchess, and yet not as bad as the orphans in Calais. Everything is relative. The circumstances that surround each asylum seeker's story are varied and specific to the individual, but all are globally homeless and on the outskirts of what we consider normal civilian life.

Masi and her brothers were moderately political in a country that doesn't favour freedom of speech. The equivalent would be accusing anti-war protesters of being terrorists with anti-government intent, Guy Fawkes style. They were the *Guardian*-reading kind of political. 'Political' changes with context, and, in Masi's context, to demonstrate peacefully was to sow the seeds of rebellion, dissent and revolution.

When Masi paints, she is like a demure angel. Steadily she gathers her tools for the day – paints, brushes and a canvas. In the later stages of her pregnancy she selects her materials slowly and moves with ergonomic precision. Nothing goes to waste, neither her energy nor the amount of paint she puts on her palette.

Masi, like many members of the New Art Studio, travels across London, two buses each way, to be with us in a place of sanctity and sanity. We welcome mother and unborn child, an embryonic member of the studio, as full of promise as a newly stretched canvas.

When we first met I asked Masi if she had painted before. She modestly replied 'a little'. Now she paints slowly, counting her time. Nine weeks, twelve weeks ... She waits in line and goes from one centre to another for check-ups and scans. Meanwhile, across London, the duchess with the same due date is having a rather different experience, with direct access to the best care, the most luxurious of baby showers and the most elegant maternity wear. This too has its price in terms of privacy, of course. But the basic difference in experience is profound.

Carefully picking her way through the London hubbub, Masi arrives at the studio proudly displaying her 'Baby on Board' badge. The badge provokes much discussion. 'On board?' people ask. 'Like a ship?' Yes, like a mother ship. They are surprised that women feel they have to wear a slogan explaining their situation in order to get respect.

Touching her brush with the paint like a cat licking milk, Masi begins.

She has clearly painted more than a little.

I'm made aware of the endless nuances of culture, working at the studio. The sayings, the holidays, the customs we take for

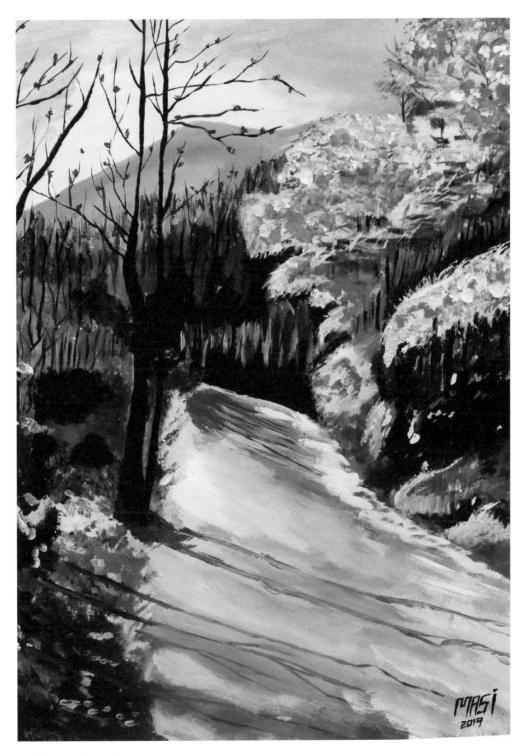

Coming Home by Masi

granted most of the time. The UK's history is very present. 'Bank holiday' still confuses members of the New Art Studio. I often don't have comprehensive explanations and berate myself for not knowing more. It actually makes me feel very un-British. I'm in the dark along with them – it's just that I've just got used to it.

Masi's paintings are illuminations. They are technically good, they are beautiful, they are sublime. The sun-drenched path in the woods and the vibrant tulips are Renaissance in feel, like Caravaggio's fruit bursting out of the page to greet us. The light in her paintings ricochets from one place to another, and ultimately returns to its source – her eyes.

Masi is currently single, pregnant and living in a studio flat which she often shares with her elderly mother. The authorities see the 78-year-old as the problem, the issue, the riddle to be solved. She has not been granted asylum, was evicted from her NASS house, and is now in the process of re-applying. She is in that dreaded nowhere place with in-between status, unable to return, unable to stay and contribute. She is officially homeless and moves between Masi's studio flat and her son's student accommodation. She is no more threat to international security than Masi's unborn child.

This dignified, elderly lady, who doesn't speak any English and paints flowers quietly, was in the UK visiting her children. On her return home there was an issue with her photo. Her hair was not covered sufficiently. A woman's hair is so strongly connected with her sex that even an old lady's hair must be hidden from the male gaze. Failure to do so can and does cause public outcry, a punishable offence that can involve flogging, stoning or imprisonment.

Masi tells her mother's story with poise and smiles continuously, never letting emotion get the better of her composure. She tells us that on her return home her mother was pulled over and questioned about her visit. Her hair provoked the initial suspicion, but her continuous contact with her offspring confirmed her position of dissent. From our emancipated position the story sounds Orwellian or – depending on one's perspective – Monty Pythonesque, but in reality it is simply terrifying.

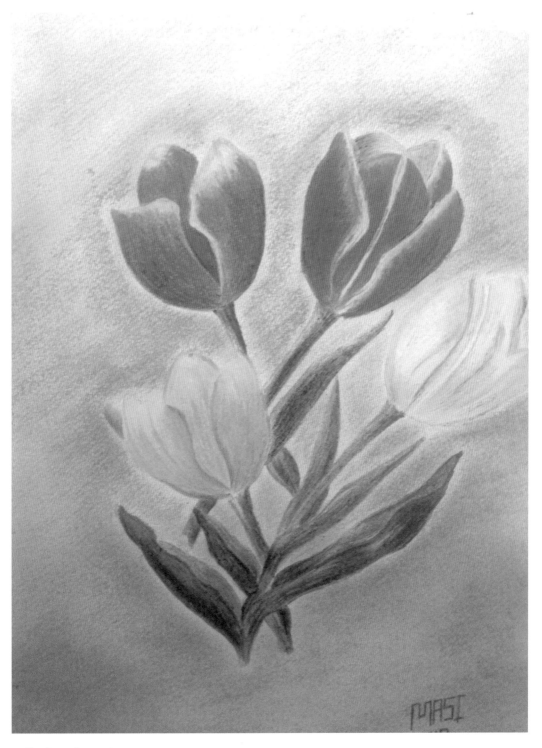

Tulips for You by Masi

How does Masi remain so calm and tranquil in these insecure and constrained circumstances? 'Yes, I sleep on the floor, my mother has the bed,' she says without a hint of disturbance or discomfort. Naively I say: 'But you are six months pregnant.' 'It's a studio flat, what else can else can I do?' she replies. For the members of the studio there are many things that simply have to be accepted. The freedom to fight rests with the safe.

Six months, seven months, eight months in and Masi still arrives to paint. She comes with no news of better accommodation or of her mother's case proceeding. She is a living, waiting pregnancy with no guarantees. Despite this she comes with smiles and light-heartedness. At the studio people naturally make tea for her, clear up for her, make her as comfortable as possible, so she can continue producing her celestial paintings. In the Jewish tradition all pregnant women are treated like royalty, and that seems to be the way in the studio. The belief is that, as the Messiah has yet to arrive in human form, any pregnancy might result in him or her. No need to declare 'baby on board' in order to get respect. And so it goes and so it grows ...

As the due date approaches, so does our exhibition: 150 paintings from the New Art Studio. Everybody joins forces; we have days of collective selecting of paintings, collective naming of paintings, and finally collective hanging of the exhibition. By now we are seeing less and less of Masi. The due date is nearly upon us. Any day now.

The lead-up to the show is spent in anticipation, preparation, fear and excitement. As a new life approaches this earth, we gather the 150 paintings that have also been waiting to be presented to the world. The studio group gathers to curate the show, to bring life to an empty space. The room and walls soon fill to the brim with an infinite display of colour, line and form.

In the meantime Masi paces her tiny pod-like space, waiting for a sign or a movement that will alert the beginning of the beginning.

Everyone is excited to see their work changed by the context. The move from our messy studio space to the clean gallery walls gives each image the respect and dignity it deserves. True to form,

it is an eleventh-hour affair, and as we hang the final pieces the clock strikes midnight.

Still no sign of our newest member ... Any day now.

The exhibition is a roaring success; a full house of interested and inspired members of the public. Members of the studio mingle with strangers who ask about their work, their processes, their inspiration. We have drinks and snacks and opening speeches. It feels just like any other private view in a gallery in central London, and it is.

Any image is open to interpretation; the meaning attached to an image says more about the viewer than the creator. Our shy artists smile and agree with whatever the member of the public is asking: 'Is it a dream, a memory?' It is whatever you want it to be. The New Art Studio members feel proud to be something other than the over-used, demonised idea of 'asylum seeker'. Now they can call themselves artists.

And then the 'any day now' does finally dawn, as it has to. Donations of baby clothes appear with our new volunteers, and we eagerly await the physical presence of the new arrival. But Masi still has to travel two buses each way to present her beautiful baby and receive our good wishes and donations.

Congratulations, too, to the royal duchess who does so well, attending events and opening galas, being whisked around the world doing good deeds for charity. She is compassionate, like her husband, and seems determined to do what she can in her position. As I watch the announcement of the royal arrival on TV, I notice the 'royal easel' for the first time. This easel is erected in the grounds of Buckingham Palace, displaying the royal baby's name and time of birth.

We too have a special easel. It awaits the return of Masi, when she has the time, the strength and energy to pick up her brush and touch the canvas again. When, full of new life, the illuminations will resume.

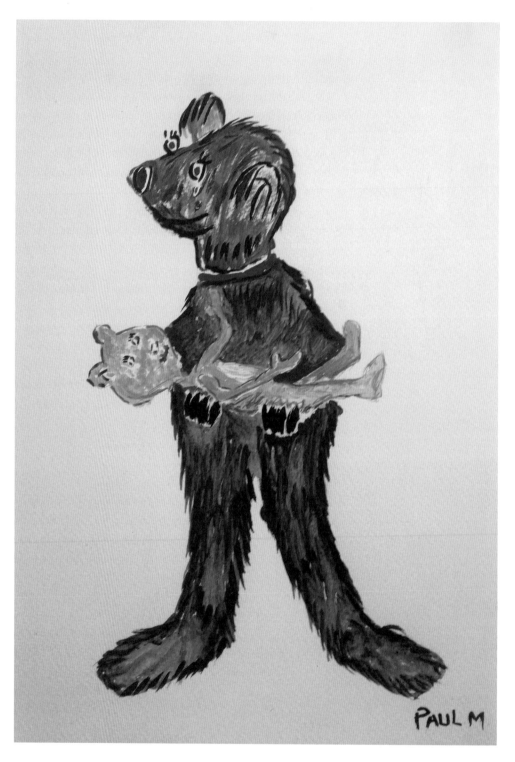

Crying Teddy by Paul

PART THREE

NO WAY OUT
BUT THROUGH

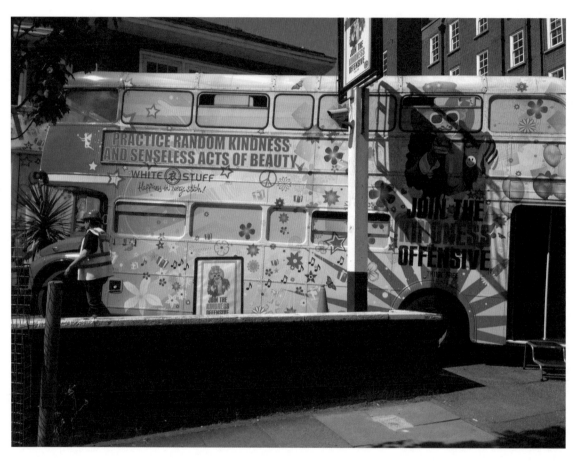

Our tranport for the day out

12

LIFE OUTSIDE LONDON

How nature can soften the blows of trauma

Most members have never left London. It's extremely hard to go anywhere when you don't speak the language and live on vouchers to the value of less than £40 a week. Travels are limited to registering your existence at the Home Office in London Bridge or Croydon, often terrifying and humiliating experiences that could lead to detention or deportation.

The idea of countryside, of places without streets or cars, of fields and trees and sea, is as unreal as a movie on TV, unobtainable and out of reach like a dream.

However, the studio is lucky enough to have a supporter who lives in a cottage outside Oxford. Every year she hosts us for a day of being in, and painting pictures of, the natural world. These days out are celebrations. A sense of euphoria settles on the group as we picnic and paint. Out here the artwork takes on a different touch; it is looser, freer and rougher round the timeless edges.

Nature sparks conversations of home, often stories of happier times before trouble set in. Stories long and safely buried in faraway soil; it's too painful, on ordinary days, to remember the happy times. Some cry as they tell their memories – simple things like growing vegetables, the peppers, the courgettes, the chickens in the yard.

Before the soldiers came.

In June 2017 we received our invitation to Oxford again, but had no means of getting there. Funds, or the lack of, have always played a

major part in how the studio operates. Often people ask, 'Why don't you have another show? Go on a gallery visit? Open for an extra day?' The reply is always the same. Funding. Funding. Funding. Somehow the studio survives on the proverbial wing and prayer. These trips happen in the same vein. Something will present itself, I thought, as I made my daily trips to work up and down the Camden Road.

On this particular day I was halted in my tracks by the striking scene of an old Routemaster bus parked up outside a disused cafe. I stopped to gaze in awe at this vehicle, painted in psychedelic colours reminiscent of Ken Kesey's beatnik bus from the 1960s. The group who owned it had taken possession of an old cafe and turned it into a free bookshop, complete with sofas for lounging and reading. How lovely, how community-spirited, I thought. With the decimation of libraries I was excited to meet a group that held books in high esteem and planned to pop in during my local ambles.

And so we got chatting, I told them about the studio and they were intrigued. How could they help? I told them how our lack of funds was halting our trip to Oxford and quick as a flash they offered us the use of the bus.

What, it moves?!

The solution to our dilemma was parked outside. And yes, they could drive us – they had an allocated driver for community group outings. Yet again we were saved.

I explained our good fortune to the group and we congregated early on Monday morning with our packed lunches and art materials. We boarded the bus, which turned out to be as much fun inside as it was outside. It even had a jukebox. The driver and conductor were genial and supportive of our excited, motley crew.

As you might imagine, a London Routemaster bus, brightly painted in psychedelic colours and crawling along the A40, provoked some attention. Drivers beeped their horns and gave us the thumbs up, while inside the group was ecstatic. What sheer fun! Unsurprisingly, the packed lunches came out well before we arrived. People had made delicious specialities from their countries and we chatted, ate, sang songs and bonded. It was a great escape from the restrictions of the Big Smoke, and people opened up as the ribbon of the road unfolded.

Sketches from nature

When we finally arrived, our host was as welcoming and generous as ever. In a carefree mood we parked the bus in a field and walked across a sunny meadow to the table and chairs she had laid out under a gazebo.

We drank homemade lemonade and painted the flowers and the sky. It felt like a *Swallows and Amazons* idyll. I thought back to our days in Finsbury Park when we had no studio, and felt safe and relaxed in our new security. How far we had come …

These beautiful trips to the country always allow for deeper, more vulnerable and exposing conversations. Nature softens the blows and cradles the wounded. People went off in small groups to explore, and Jon took the adventurous ones out in the little river canoe. Laughter, chatting and hilarity ensued. Shoulders and guards down, this was our day.

Wallid and I wandered about in the long grass, making our way to the river where it meandered and curved, the same soft English meadow on either bank. We watched the dragonflies and kingfishers frolic with the butterflies, and our world felt good.

'So beautiful,' he whispered. 'It reminds me of some place, I don't know the name of the country but the border was on the other side, and we slept in a little house and we ran through the field at night … We knew soldiers were watching us, but I don't know what soldiers they were.'

The journeys people take while running for their lives often seem to happen in places of natural splendour – places where free people go hiking, mountain biking and camping, places normally associated with vacations, time away. It's natural, then, that memories and associations come to the fore in beautiful surroundings.

Our lovely host served us tea and cakes, the members felt loved and welcomed. We gathered our paintings for our usual 'talking time' and the beauty of repetitive rituals held and nurtured us all.

All good things come to an end, and our magical day did too. And so we packed up our brushes, paints and food containers and made our way across the summer meadow escorted by the butterflies. We said our goodbyes and words of gratitude to our host and climbed aboard the bus. Everyone on, we counted heads, all good to go. But the engine wouldn't turn, the bus wouldn't start. We weren't going anywhere.

Still in good spirits, everyone on the upper deck made their way downstairs. Who cares, was the feeling. Let's stay here! Look at our beautiful field – our field of dreams …

With everybody off again we chatted and played games, sang songs in Farsi, Pashto, Russian and Chinese, called the AA and went for toilet breaks in the little pub across the towpath. Jon and I put our heads together as the day turned to dusk. The AA man still hadn't arrived. It was now 8 p.m. and the mood was shifting as the sun began to set. The whole scenario started to feel uncomfortably real as the seriouness of our situation sank in. It felt as though we were re-enacting the predicament of so many refugees stuck in fields across the world. Maybe we should try and get everyone back to Oxford, where we could get a regular bus back to Marble Arch? Maybe we could hitch the half-hour journey? The driver reassured us: don't worry. Once the AA man arrives the bus will be fixed in a jiffy.

We went on waiting, running out of songs and games.

Finally Jon and I had to face the fact that, responsible for nine vulnerable adults, we were stuck in a field in the darkness with no means of transport, no bedding, no torches, no tents and barely any coats.

At around 10 p.m. the AA man arrived. Our saviour, our angel had descended. Don't worry chaps, help is at hand and we'll be on our way in no time at all.

But life is rarely that simple.

The bus, it transpired, was well and truly stuck. Something about a broken chassis. The driver was feeling a lot less genial and apparently it was all my fault for instructing him to park in a field in the first place. Success has many fathers, but failure is indeed an orphan.

Luckily the AA man came good and ferried us to the Oxford Megabus in small groups. We rolled into Marble Arch just before midnight. The usual mood of stoic acceptance and good cheer was restored and everyone checked phones for night buses to their NASS accommodation in Stratford, Enfield and Uxbridge. I felt dreadful that our day had turned into a parody of their terrible journeys to get to the UK. As we dispersed at the station I made them all promise to text me on arrival, wishing more than ever that I could say 'When you get home.'

Inside My Mind by Eva

So Deep, So Far by Anon.

Red Riding Hood by Anon.

IT'S NEVER OVER

The aftermath of asylum and refugee living

When I was first asked to run an art studio at the refugee charity, for asylum seekers who were victims of war, imprisonment and torture, I was nervous. I expected graphic representations of burning villages, scenes of battlefields or prisons ... But no. It turns out the expression of human experience is much less obvious than that. It is subversive.

Making art is an emotional response to extreme situations. It doesn't tell a literal story. It suggests. We exist between the lines.

I am continually amazed at the incredibly high quality of artwork made at the studio. These paintings have an integrity rarely seen in galleries these days. They hit the soul, whisper to the viewer what life might be like living in fear, living with loss, haunted by visions of soldiers and officials. They are not explicit, they are not obvious or crude, but have a sublime subtlety that takes the viewer to other places. Some offer escape routes via fantasy dreamscapes. Others are devastatingly gentle, poetic suggestions of life behind bars.

Art-making of any weight so often comes from a dark place, a place of struggle and discontent. And for our artists the process is ongoing. Saying someone has 'lived through' something implies they have now come out the other side. But for so many, there is no other side. Tyrannical governments and despots exert their power from afar, across continents and oceans. We hear regular stories

of family members back home being imprisoned for things studio attendees did years ago. Things like going on a demonstration, taking off your headscarf, writing a poem; liberties we take for granted. It's mafia-style behaviour. If you appear to have escaped, they will go after the ones you love. It takes minimal empathy to understand how this continuous threat of terror feels.

So freedom becomes a thin word, without the weight we might like to believe. Yes, you may have your status, you may officially be a refugee, you may have a cleaning job or you may be working for very much less than the minimum wage, but what is this freedom if you still have to have clandestine phone conversations with your parents in another country? If any contact has to be hidden in case your family is herded up for associating with you?

Those involved say this: the sense of powerlessness from afar while your brother or your mother takes the blows is worse than being in personal danger. One woman, who had been serially raped by soldiers, said: 'You know what hurts the most? They killed my dog ...'

The fear of repercussion keeps these artist hidden. They want to show their work but remain anonymous in order to keep themselves and their families safe.

International espionage is alive and real.

In this context, the only place of safety is the studio. And the only place of freedom is on the page.

Triangular Trap by Shaka

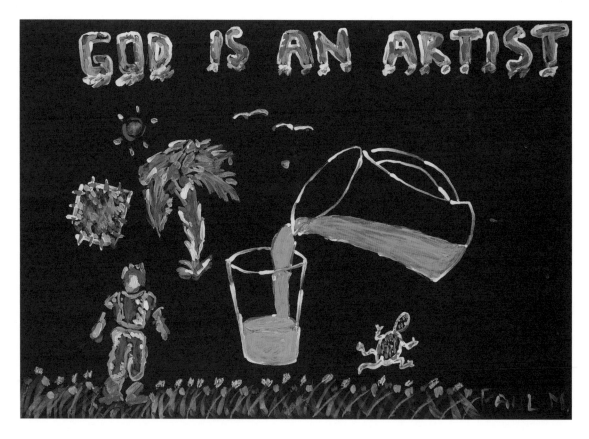

God is an Artist by Paul

Lifeline by Shaka

Asylum Living by Shaka

14

ONCE UPON A TIME

The origins and ethos of the New Art Studio

The thinking behind the New Art Studio began almost three decades ago. I had just qualified as an art psychotherapist from Goldsmith's College, University of London. During my training and since qualifying I have always stayed away from mainstream psychiatric thinking. I have always known I wouldn't be comfortable working in a hospital or day centre that adhered to binary beliefs of the 'you are mad, I am sane' variety, or any place where human experience and feelings are diminished to a label found in a book and numbed with medication.

Our understanding of madness is dependent on time and place. It is culturally constructed. Only a few decades ago homosexuality was a criminal offence and a mental health disorder. In some countries it still is. The experience of madness is affected by our social and financial position in society, and by the norms of the day. When I qualified, I longed for a place that matched my thoughts and feelings – that most people at times in their lives feel mad, unhinged, disassociated, anxious and depressed. It's what happens next that counts.

What happened next for me was crucial. I came across the Studio Upstairs, then based at Diorama Arts, founded in 1988 by Douglas Gill and Claire Manson. The Studio Upstairs is now a large therapeutic arts community for people suffering extreme states of emotional distress and has moved to a square in Dalston,

East London. Open all day five days a week, it is a thriving creative and therapeutic space for people who may otherwise be sectioned in a psychiatric ward or medicated at home. This arts community meets as people and artists rather than as therapists and patients. It is influenced by R.D. Laing, the radical psychiatrist active in the 1960s, and by the Philadelphia Association, a group of philosophical psychotherapists who challenge traditional psychiatry and the diagnosis of mental health issues, emphasising the importance of community, integration and agency.

The Studio Upstairs incorporates philosophy, spirituality and the arts in attempting to understand people's current emotional situation, and it respects that going mad can sometimes be the sanest response. Through art-making, including drama, dance and poetry, overwhelming states of emotion are held and normalised. By accepting these emotional states as an essential part of human experience and removing the label and stigma of mental health, authentic conversation and relatedness can begin.

The distance that is often deemed essential between professionals and clients – referred to as boundaries – can be counterproductive and alienating. At the Studio Upstairs nobody is pathologised or patronised. Thoughts and feelings are heard and shared through the process of art-making. Members and art therapists work alongside each other, immediately creating a level playing field across which open, honest conversations prevail as people navigate the complexities of relatedness. By engaging in individual art processes in a supportive and social arena, emotions arise and are held by the safety of the group. This environment of creative energy and discourse is in direct opposition to the psychiatric settings I experienced on study placements. They had felt more like prisons – a holding place with locked doors for people who thought differently.

So often, people simply want acceptance and validation of their experiences and feelings in order to feel sane.

Even before I began to work as a therapist at the Studio Upstairs I had a sense of homecoming. Here were kindred spirits who manifested my own beliefs: that art-making is a leveller; that it defies notions of separation between people; that it reminds us of our common humanity.

During my time at the Studio Upstairs, I was approached by Diana Brandenburger, an art psychotherapist who worked at a large charity for asylum seekers and refugees. Diana spent a day with us and immediately absorbed the combined atmosphere of inclusion and serious art practice. The parallels between her members and ours were clear: both refugees and people with mental health issues are misunderstood, feared and ostracised.

Diana went on to create the Open Art Studio for asylum seekers and refugees at the large charity she worked for, based on the same model as the Studio Upstairs and emphasising human interaction regardless of race, religion or UK status. She adopted the philosophy of inclusion and made it a priority for people who are profoundly excluded.

Diana successfully ran the Open Art Studio for six years until she was diagnosed with cancer. Always a wonderful, straight-talking woman, in the weeks leading up to her death in 2008 she called me and explained, in her usual matter-of-fact way, 'Tania, you know I am dying ... I want you to take over the studio. Don't be nervous ... These people have endured the most horrific experiences, but when we all make art together they are just like you and me.' I had never worked with asylum seekers and refugees before and I was indeed nervous – but my father had been a refugee from Nazi Germany and I had been brought up in the shadow of what it means to be adrift, expelled, outside ... I added this understanding to my ten years' experience at the Studio Upstairs and I agreed.

So it goes that Diana passed the baton to me. I ran that studio for six years and felt completely at home. And when the organisation's structures changed and the group was closed, I promised we would start our own – and we did.

Which brings us back to our months in the park, and the birth of the New Art Studio ...

Guiding Me by Wallid

AND NOW …

What happens next for New Art Studio members

And now, only five years since we officially launched the New Art Studio, we are a thriving community. We are still restricted by funding limitations and only open one day a week, but every Monday we have a full house. There are twelve members on the register and another five on the waiting list. We have secured funding from Allford Hall Monaghan Morris (a prestigious company of architects in East London), Lloyds Bank's start-up initiative and the Big Lottery Fund. We have had eight exhibitions. We have shown work at the Ben Uri Gallery, the Garden Court Chambers (as guests of their human rights team), Islington Arts Factory and Sheffield Arts Community Centre.

We were invited by the Migration Museum in Vauxhall, South London, to be Artists in Residence during early 2019. They provided free studio space for our members for six weeks. This encouraged our members to work independently, outside of the safety of the New Art Studio. This residency had very positive effects on the members' confidence and sense of self-worth. For most of the residency, Jon and I were not present at the Migration Museum, but the members attended with vigour and enthusiasm. They fully appreciated the chance to make art on more than the usual one day a week and, together with us, held art-making workshops with visitors. These weekend events were well attended and an

opportunity for adults and children to learn more about the New Art Studio, migration, asylum living and the power of creativity.

In March we held a large exhibition of 150 paintings at the Islington Arts Factory. We had called our 2017 show 'Thirty-Six Pounds and Ninety-Five Pence' which is the amount that asylum seekers then received each week in vouchers from the British government. This time the members decided to choose a different name. We called this show 'Barriers'. From July to September 2019 we exhibited at the Migration Museum once again. These outside links are vital to the life of the studio.

In the studio, we have had art psychotherapists on placement; two art psychotherapist volunteers have become part of the team. We are now a bona fide project, respected both in the art psychotherapy world and the world of asylum seekers and refugees.

It's incredible to think how far we've come, and that we are now able to offer regular yoga sessions, English lessons and life-drawing workshops as part of a Monday for our members, and just as incredible that Jon and I have a steering committee. It has been a pleasure and an honour to watch our idea unfold and evolve.

As for our members, change comes slowly. But everything changes eventually, given enough time. Even after a person's status moves from asylum seeker to refugee, things are still complicated. There is often an initial wave of relief that they cannot now be deported or detained, they can officially work, study and integrate. But unfortunately that feeling is short-lived as they are immediately evicted from their NASS accommodation. Now they are officially homeless and have to seek both housing and employment immediately. This can be a very difficult time. Suddenly, often after a period of around ten years, they are free to engage with society. The issue is that, after ten years of not being allowed to do anything, they now have to do everything. In this situation, refugees are as dependent as newborns, thrown into society with few life skills or connections thanks to the restrictions imposed on them when they were seeking asylum.

Despite these ongoing restrictions and barriers, our members do start to engage with the mainstream. They seek and find

Goldfish Bowl by Anon.

Life Drawing by Benjamin Croft

employment, they enrol in colleges, and they often volunteer for vulnerable groups.

Wallid finally left his uncle's kebab shop, passed his driving test and is now a delivery driver. He is still quietly spoken, but a gentle fire glows inside him. His paintings continue to have a profound effect on anyone who sees them.

After nine years of limbo-living, Reyhana, who successfully raised her child in NASS accommodation, was finally granted indefinite right to remain. This is the first step towards becoming a refugee, which ultimately leads to citizenship. Most importantly, it means she cannot be deported. So she and her son are safe, and she is free to work. She has embarked on the difficult journey of seeking and finding employment and a secure home for herself and her son.

Eva, the abstract artist, has stopped all medication and consequently paints sitting upright with a straight back. Her images reflect the clarity and structure that she has found in herself. The paintings stay within the frame of her page and, though they are still abstractions, they appear to suggest people in conversation. Eva now attends college, where she is studying to become a translator. When a new member recently arrived at the studio unable to speak any English, Eva translated our initial interview. She explained that the young man was talking about how isolated and afraid he was and I said to her: 'Oh, that's how you felt when you first arrived.' Eva corrected me straight away: 'No. I don't want to share my experiences with a stranger.' In that moment I knew not only that she was right, but that the studio has done a successful job in giving her a voice and a choice. She now has the confidence to know and declare her limits.

Eva also works as a volunteer with young children. She recently discovered Frida Kahlo and senses a kindred spirit.

I am so proud of all the members who attend the New Art Studio. I am in awe of their courage, their quiet determination and their ability, despite everything, to remain creative.

Viva the New Art Studio.

A Virtual Studio

Just before this book was published, COVID-19 hit our shores and lockdown closed our doors. The last time I met the members in the studio was on 15 March 2020, when I had to explain that the studio – indeed, the whole world – was stopping. No, I didn't know how long for, nobody did. I divvied up art materials so the members could work at home and we said our strange farewells. Like an umbilical cord cut, we parted.

It reminded me of earlier closures, of our meetings in the park, but this felt universal. The experience of 'Stay at Home' differs depending on your home. Some members have suffered terribly during this lockdown, so frightened by government warnings that they haven't dared to venture out at all. Others slipped away in their depression and solitude. Old fears were revisited: better safe than sorry, lay low, don't move. There is no group response; each individual has their own experience of fear and insecurity. Fear is the most base of feelings and the response is primal – to survive.

Currently there is palpable anxiety that drifts through our clear skies. The planes and cars may have been erased, but in their place is an unseen virus and an equally sinister unseen anxiety between people ... a 6-foot distance of suspicion.

From the perspective of an asylum seeker, the world has always been closed, people have often been suspicious of them, and feelings of insecurity are habitual. The current restrictions may feel like a prison within a prison, or a global re-enactment of their previous restrictions, terrors and isolation. If you step outside, you could die. The threat of death is broadcasted every day; it's an existential reminder of things they know too well.

Our artists are emotional soldiers, accustomed to extreme sea, sky and land changes, and yet in these troubled days they are tired, frightened and penniless. Most live without any outside space. The charities they relied on to top up their mere allowances have closed and food banks are stretched.

Still waiting by Reyhana

So lockdown and 'Stay at Home' may sound inclusive and jolly to some people, with stories of baking cakes and video calls, but as usual it's a matter of finance and status. For those with neither financial safety nor any legal status, this time is a lonely psychological and spiritual war, with an army of one. As always, the most vulnerable are affected the most.

We kept the group connected and united; as usual our connection and dialogue is through our art. The paintings are a communal adhesive. Every Monday our WhatsApp group pings as new images flood in. Repetitive patterns of women alone and familiar themes emerge ... the members have been here before, feelings of isolation and insecurity return. These images, created alone, are collectively the essence of our connection. In addition to their artwork, the shared life stories of the members unfold via messages, paintings, photos and videos.

In this lockdown, everything is virtual; it has created a different reality where your screen becomes a lifeline. The short-term effects are isolation and a desperate attempt to recreate what is no longer present. The long-term effects are yet to be seen. Reality as we knew it has become an idea, matter becomes spirit, and our studio becomes ethereal, but still exists even when there is no studio space and no physical meeting ... but it's just not the same.

This separation has highlighted the importance of social meetings and the need to see a friendly face is ever more pressing for these artists. They have lived through wars and seen societies ripped apart and shattered; the familiar is far away and the past has always been another country.

As lockdown measures started to ease, priority was given to those most in need at the Islington Arts Factory and on 8 June the New Art Studio reopened like a phoenix rising (again!). We separated the tables and provided everyone with hand sanitiser and masks. The members picked up their paintbrushes and resumed just where we had left off, as if no time had passed at all.

AFTERWORD

On being the daughter of a refugee

I am not a refugee. But the word itself and the ideas it embodies are fundamental to my understanding of the world. I live in the shadows and the aftermath of war.

Many members of my family were killed in Auschwitz concentration camp. My grandfather survived Sachsenhausen, a work camp outside Berlin. He had fought for the Germans in the First World War; twenty years later he was on their death list, simply for being a Jew.

My family were Berliners. My grandmother, Edith Bach, was a famous soprano, known as 'The Nightingale of Berlin'. She was banned from singing opera for simply being Jewish. The family felt so assimilated into Berlin culture they barely knew they were Jews until Hitler reminded them. My father, with his brother and parents, escaped Nazi Germany in 1939. He was German, *Juden*, enemy alien, refugee, British citizen ... all of the above.

Tania Kaczynski by Sam Menezes.

The feeling that dominates when you are exiled from one country to another is that of outsider. You are a guest at best, welcomed or perhaps not depending on the prevailing mood of the host nation. You don't feel you belong. You have no history here, and your past history has been severed. Identity is sometimes not what you feel about yourself. It is what others tell you that you are.

So when people ask: 'Where are you from?' – which happens often and understandably because of my name – I think: 'How long have you got?'

My mother's parents came from Poland and Portugal, escaping the pogroms at the turn of the century. Most Jewish history is one of persecution, escape and exile. That's if you're lucky. I was born and bred in London, and grew up enjoying everything the city has to offer. But I never forgot where my family came from and why. I experienced low-level antisemitism, though I never told my father. I didn't want to remind him that it lurks and brews and surprises you.

The shadow of the Holocaust was never far from my family home – strange accents, back-to-front grammar, heavy food and heavy moods. I longed for a different, happy history, cousins whose lives were full of sailing and ponies, who didn't have tragic endings. Instead I had relatives who were remembered by their concentration camp or survival story: 'You remember Daddy's cousin Joseph; he buried his own dead parents when he was fifteen, hiding in the woods of Poland ... Now please finish your homework ...'

With this legacy, the New Art Studio and the people I meet and the problems they face feel familiar to me, just one generation removed. The backdrop is the Middle East or Africa or Russia instead of Europe but the terror and the sense of misplaced existence is familiar landscape, and the evil horrors and sadistic behaviours of government forces don't shock me. I know that the world is a fragile place and identity can change and shift to suit a regime's mood. I know how humankind can be, and it's not kind at all.

The only certainty is that we are all citizens of the world.

I hope that one day this will be enough.

CONTRIBUTORS

All the paintings in this book were made at the New Art Studio by asylum seekers and refugees.

They are: Paul, Masi, Eva, Reyhana, Lela, Wallid, Shaka, Brahmin, Akram and Benjamin Croft, as well as two who wished to remain anonymous.

Each artist has contributed to making this book and making the New Art Studio such a special place.

Lonely Place by Anon.

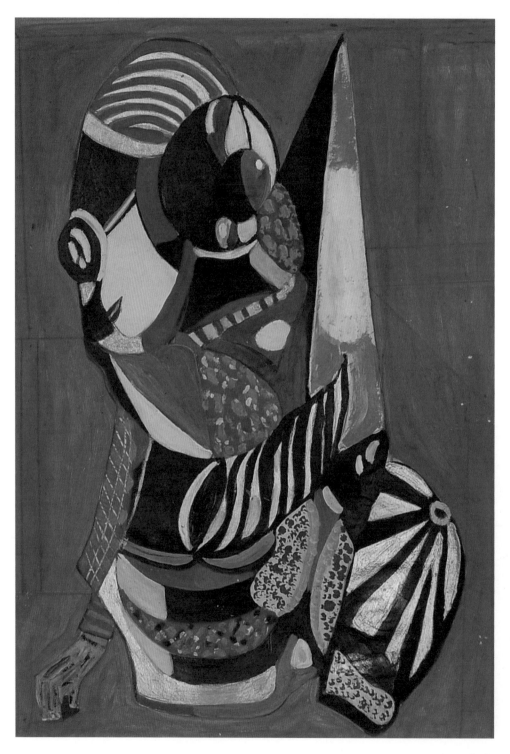

Pattern Creature by Brahmin

ACKNOWLEDGEMENTS

First and foremost, my appreciation and admiration go to all the inspiring members of the New Art Studio. Thank you for sharing your stories.

I also want to thank Alison Chandler, my writing tutor and editor. Without her patient coaching and encouragement, this book would have remained an idea, asleep in the recesses of my mind. We met at a learning fair in a North London community centre. Among the chess and cookery teachers I bumped into Alison, who was promoting creative writing courses. Like the New Art Studio, acorns can and do turn into oaks. I thank Alison for her patience, guidance and friendship during the writing of this book.

I would like to thank Jo Sovin for her technical support and clarity of thought. Jo kept me calm with her optimism and solid faith in this project. Thanks also to Philip Wilson for doing justice to the artists' work with his skilful photography.

Thank you to Valentina Krajnovic, who has supervised and guided the New Art Studio with insight, wisdom and eternal optimism.

Angela Hobart at The Sutasoma Trust took a chance on us in the very early days and continues to provide great support, for which I am very grateful. Likewise the Allford Hall Monaghan Morris architecture practice, which has supported us so generously.

Finally, many thanks are due to Jon Flanagan for all the years of great conversation, and for his gentle encouragement to complete this book.

Through the Tears by Benjamin Croft

FURTHER READING

Online

Migration Museum www.migrationmuseum.org

The New Art Studio www.newartstudio.org.uk

Studio Upstairs www.studioupstairs.org.uk

In print

Cobb, Noel, *Archetypal Imagination: Glimpses of the Gods in Life and Art* (Lindisfarne Books, 1992)

Frankl, Viktor, *Man's Search for Meaning: The Classic Tribute to Hope from the Holocaust* (Hodder and Stoughton, 1962)

Kandinsky, Wassily, *Concerning the Spiritual in Art* (Dover Publications, 1947)

Karpf, Anne, *The War After: Living with the Holocaust* (Faber, 1996)

Laing, R.D., *The Divided Self: An Existential Study in Sanity and Madness* (Penguin, 1960)

——, *Sanity, Madness and the Family: Families of Schizophrenics* (Penguin, 1964)

——, *The Politics of Experience and the Bird of Paradise* (Penguin, 1967)

——, *Mad to be Normal: Conversations with R.D. Laing* (ed. Bob Mullan) (New York University Press, 1995)

Yalom, Irvin D., *Existential Psychotherapy* (Basic Books, 1980)

If you've enjoyed reading about the New Art Studio and the fantastic artists who attend, please support us – every little helps. You can donate online at newartstudio.org.uk.

I Want to be Strong by Anon.